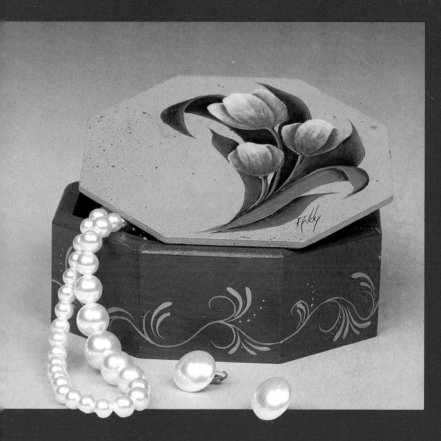

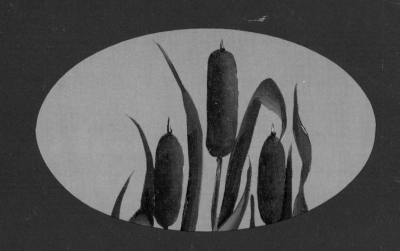

Country Cattails

Bright Tulips

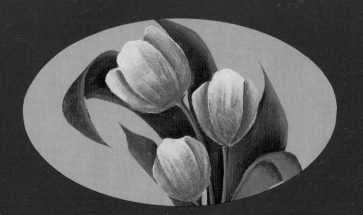

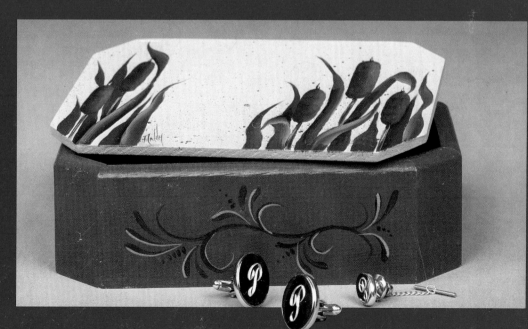

Mommie's Strawberries Worksheet

Strawberries

Titanium White highlight

Napthol Crimson shading

Base bracts in Hookers Green

Alizarin Crimson deep shading

Accent of Cadmium Red Light

Highlight bracts in Permanent Green Light

Seeds are Cadmium Yellow Light dot with Black line

Leaf

Base leaf in Hookers Green

2 3
1 4
 5

Gel applied to center

Mars Black

Blend into Gel

Highlight with Permanent Green Light

Blossom

Base coat all petals in Titanium White — shade with Cadmium Yellow Light

Burnt Umber wash

Burnt Sienna wash

Loosely place Burnt Umber dots around center

A Finished Design Grouping

Hoop Hoop Hurrah for Mushrooms Worksheet

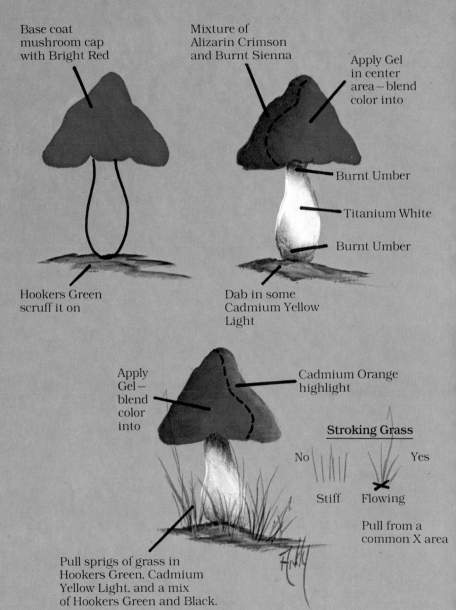

Base coat mushroom cap with Bright Red

Hookers Green scruff it on

Mixture of Alizarin Crimson and Burnt Sienna

Apply Gel in center area — blend color into

Burnt Umber

Titanium White

Burnt Umber

Dab in some Cadmium Yellow Light

Apply Gel — blend color into

Cadmium Orange highlight

Stroking Grass

No Yes

Stiff Flowing

Pull from a common X area

Pull sprigs of grass in Hookers Green, Cadmium Yellow Light, and a mix of Hookers Green and Black.

Country Cattails Worksheet

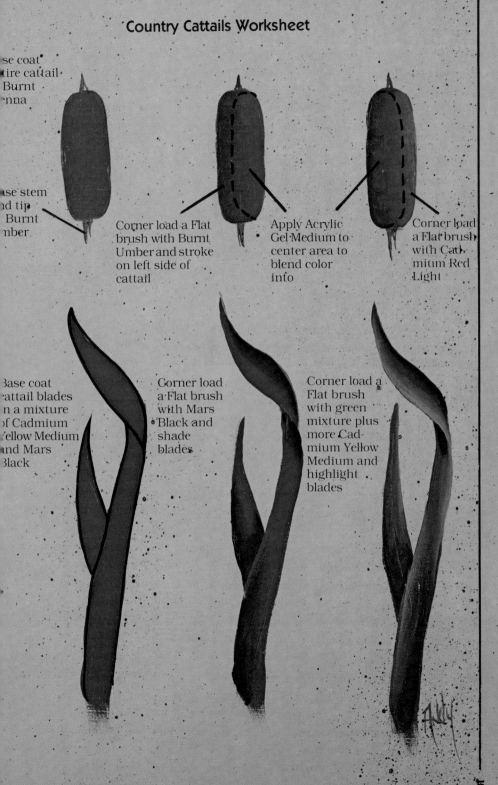

Base coat entire cattail in Burnt Sienna

Base stem and tip in Burnt Umber

Corner load a Flat brush with Burnt Umber and stroke on left side of cattail

Apply Acrylic Gel Medium to center area to blend color into

Corner load a Flat brush with Cadmium Red Light

Base coat cattail blades in a mixture of Cadmium Yellow Medium and Mars Black

Corner load a Flat brush with Mars Black and shade blades

Corner load a Flat brush with green mixture plus more Cadmium Yellow Medium and highlight blades

Bright Tulips Worksheet

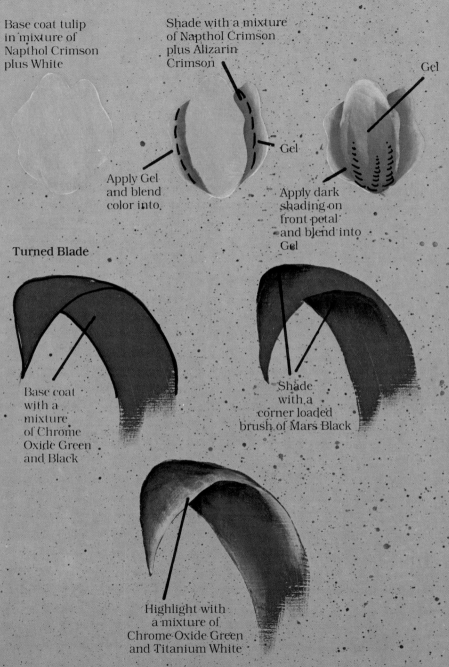

Base coat tulip in mixture of Napthol Crimson plus White

Shade with a mixture of Napthol Crimson plus Alizarin Crimson

Gel

Apply Gel and blend color into

Gel

Apply dark shading on front petal and blend into Gel

Turned Blade

Base coat with a mixture of Chrome Oxide Green and Black

Shade with a corner loaded brush of Mars Black

Highlight with a mixture of Chrome Oxide Green and Titanium White

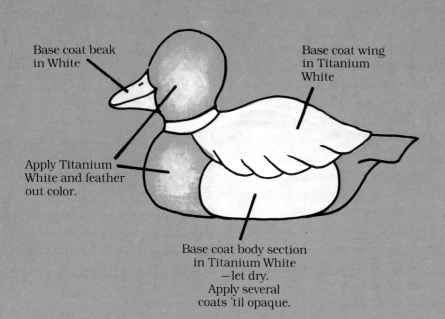

Base coat beak in White

Base coat wing in Titanium White

Apply Titanium White and feather out color.

Base coat body section in Titanium White —let dry. Apply several coats 'til opaque.

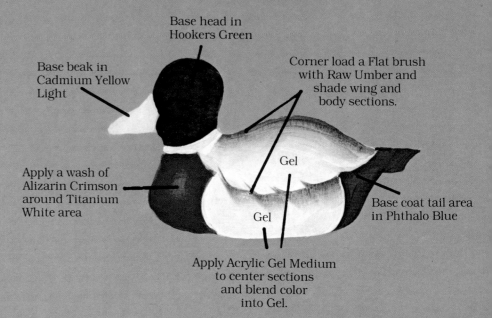

Base head in Hookers Green

Base beak in Cadmium Yellow Light

Corner load a Flat brush with Raw Umber and shade wing and body sections.

Apply a wash of Alizarin Crimson around Titanium White area

Gel

Gel

Base coat tail area in Phthalo Blue

Apply Acrylic Gel Medium to center sections and blend color into Gel.

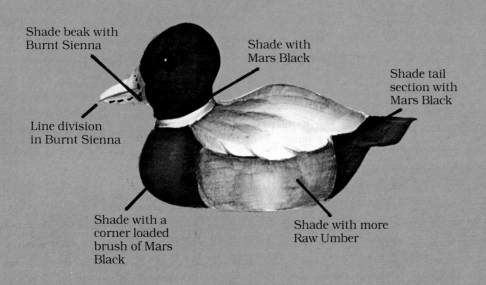

Shade beak with Burnt Sienna

Shade with Mars Black

Shade tail section with Mars Black

Line division in Burnt Sienna

Shade with a corner loaded brush of Mars Black

Shade with more Raw Umber

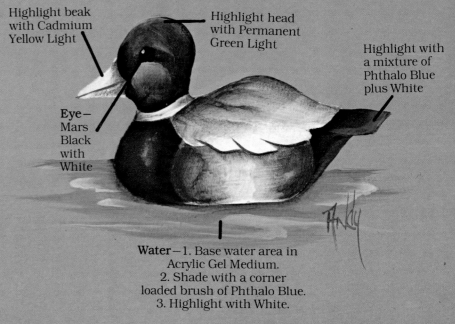

Highlight beak with Cadmium Yellow Light

Highlight head with Permanent Green Light

Highlight with a mixture of Phthalo Blue plus White

Eye— Mars Black with White

Water—1. Base water area in Acrylic Gel Medium.
2. Shade with a corner loaded brush of Phthalo Blue.
3. Highlight with White.

Priscilla Hauser Presents

Kids Can Paint Too!

by Andy Jones

CREDITS

Priscilla S. Hauser
Publication Director

Phillip C. Myer
Editor/Art Director

Dorothy Schwartz
Editorial Assistant

Jean Brubaker
Barbara Maier
Production Artists

Bill Dobos
Photographer

Lynn Dinnell
Typesetter

Printed in the U.S.A.

Permalba® Acrylics are Trade marked products of Martin/F. Weber Company.

Aqua Tole™ Finish and Transpalette™ are Trade marked products of Priscilla's Publications and Products.

First Printing, 1984

ISBN 0-917119-40-1

Contents

Contents

Color Photographs of Projects ... 2

Color Photographs of Projects ... 3

Strawberries and Mushrooms Worksheet ... 4

Cattails and Tulips Worksheet .. 5

Mallard Worksheet .. 6

Title Page ... 7

Credits ... 8

Meet the Author ... 10

Dedication .. 11

Introduction .. 12

Supplies ... 13

Terms .. 16

Basic Brush Strokes .. 19

Preparation ... 22

Finishing .. 25

Projects .. 26

Mommie's Strawberries .. 27

Hoop Hoop Hurrah for Mushrooms .. 34

Country Cattails ... 38

Bright Tulips ... 42

Mallards for Dad .. 47

Lion and Blue .. 52

Spotty Giraffe .. 56

Buzzin' Bees .. 59

Wiggly Worm ... 63

Froggy Bathroom .. 68

Lion and Giraffe Worksheet ... 75

Bees and Worm Worksheet .. 76

Frog Worksheet .. 77

Color Photographs of Projects .. 78

Color Photographs of Projects .. 79

Meet the Author

Meet the Author

Foreword

by Priscilla S. Hauser

It was the Summer of 1977 in Destin, Florida, my Summer Seminar Headquarters, I rounded the corner and entered the hotel room where, at that time, I was teaching my seminars. When I looked up, I was met by the smiling, round, angelic face of a twelve year old boy who was bubbling over with enthusiasm. This was my first encounter with Andy Jones.

Andy had written to me for a year before we met. He loved to paint and his dream was to attend one of my Basic I seminars, I was somewhat hesitant. My seminars consist of long, hard hours of study and painting—and seldom do children attend.

Andy's mother, Ann Jones, owns a charming painting shop in Tallahassee, Florida, called Calico Junction Arts & Crafts. Ann told me she thought Andy could handle the seminar. Andy sent leaves, daisies, and strawberries to me painted on tracing paper. I looked at them and decided to let Andy attend a seminar.

That seminar was a treat and a treatment for both Andy and me. I had never had a student ask so many questions in my life! Andy really kept me on my toes! Today he still does—the little boy has grown into a fine young man. Andy has taught painting for six years both to adults and children. In 1983, Andy became a Certified Degree Artist of the National Society of Tole and Decorative Painters—this is indeed a great honor. At one time, Andy was my youngest accredited teacher and has served on my National Teaching Staff. Andy does a lot of painting for me, from television preparation to actually painting seminar projects.

In this book, Andy writes so that children can easily follow the techniques—he has designed projects that kids love to paint for fun as well as use.

If you're ever close to Tallahassee, Florida, stop by Calico Junction and meet Andy—you'll fall in love with the still smiling, round, angelic face, he'll make you want to paint!!

Dedication

Dedication

I would like to dedicate this book to my mother, Ann Jones. For without her love, support, and encouragement, I would never have been able to paint.

My thanks are also extended to: Priscilla — for being who she is; Brita Darling — my first tole teacher; Dorothy Montgomery and Jeanne Steverson — the best of friends and associates.

Introduction

 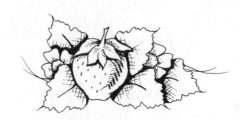 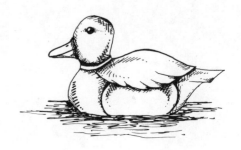

Introduction

Kids Can Paint Too! This book is a collection of simple yet fun designs for children to paint. Starting to paint at a very early age myself, I relate very well to the pleasure painting brings early in life. I have tried very hard to simplify my instructions so that young children can pick up a paint brush and discover the joys painting can bring. There is no better time to start painting than at a young age.

I have chosen to work in acrylics for they are easy to work with and clean up is a breeze. So gather up your supplies and get started.

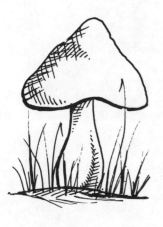 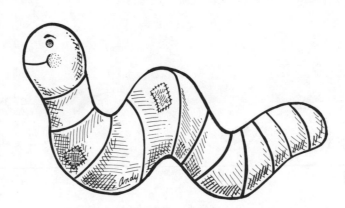 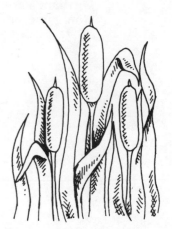

Supplies

Supplies

In this section of the book, I want to familiarize you with supplies that you will be using when painting the projects. Please take time to learn how and when to use these products and you will have a much easier time with your painting.

Paints:

All of the projects in this book were painted using the Permalba Artist's Acrylic colors manufactured by the Martin/F. Weber Company. Acrylic colors come in two forms - one being the true artist colors in tubes, and the other being "craft acrylics" in jars. For painting the actual subject matter, I used the tube acrylics and for background preparation, I used the jar or base coat acrylics.

Permalba Artist's Acrylic colors meet the requirements of ASTM Standard D-4236 for non-toxicity. Look for the AP NON-TOXIC seal of the Art and Craft Materials Institute on these colors. This is your guarantee of approved, non-toxic, professional artist colors. Permalba colors are ideal for children's use.

Permalba Artist Acrylic Colors used throughout the book:

Alizarin Crimson	Cadmium Yellow Medium	Napthol Crimson
Bright Red	Cerulean Blue	Napthol Red Light
Burnt Sienna	Chrome Oxide Green	Permanent Green Light
Burnt Umber	Cobalt Blue	Phthalo Blue
Cadmium Red Light	Hookers Green	Raw Umber
Cadmium Yellow Light	Mars Black	Titanium White
		Yellow Ochre

Acrylic Gel Medium:

You will use the Gel as a medium to blend color into. Allows shading of tones to occur easily.

Brushes:

For the painting that I do with acrylics, I use the Acrytole brush manufactured by Robert Simmons. The Acrytole brush is a synthetic "sable" that can withstand use in water. When you purchase a new brush, it is full of "sizing" or a stiffening agent that protects the brush during shipment. Before painting with it for the first time, you must remove the sizing. To do this, wash the brush in a mild soap and water solution and rinse in clean water. Never lay a brush down if it has acrylic paint in it, the paint could easily dry and ruin the brush.

To clean a brush thoroughly, swish the brush back and forth in your brush basin or water container. When no more paint seems to be coming from the brush, blot, and begin stroking on a bar of mild soap. If you can see no more traces of paint on the soap, then you are ready to reshape the brush and store upright in a glass or other container so that the bristles are not bent or resting against anything. If additional color comes from the brush, simply wash in water and repeat steps with soap.

Other Supplies:

Waxed Palette:

You will need a wax-coated palette to put your paints on and to mix colors. Do not try to use anything smaller than 9 x 12.

ph Transpalette:

For tracing and transferring patterns.

Palette Knife:

Any good quality flexible palette knife with a flat blade.

Soft Absorbent Rags or Paper Towels:

Only use *soft* rags as any rough toweling can damage your brushes.

ph Graphite Paper:

Do not confuse this with typewriter carbon. You will use graphite paper to transfer patterns onto light to medium backgrounds.

Chalk:

Any ordinary white chalk will work for transferring a pattern to a dark background.

Sand Paper:

To smooth the rough wood grain.

ph Clear Acrylic Spray:

This is used to seal your base coat acrylic.

ph Aqua Tole Waterbase Varnish:

This is used as a final varnish.

Terms

Terms

Base Coat:

A base coat is an application of paint to color an object. It is sometimes called "colorbook" painting. You will accomplish this with the largest brush that you can be comfortable with. Always base coat with your strokes going the way the object flows.

Dampen brush with water

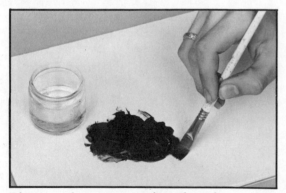

Dip or stroke one corner into the paint

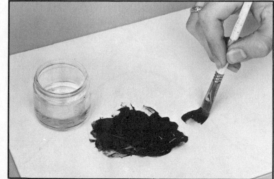

Stroke brush in short pulls on palette

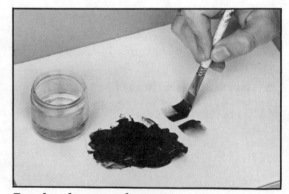

Turn brush over and repeat

Corner Loading:

This is one of the most important techniques that is taught in this book. Once you have mastered corner loading, you will be able to shade beautifully and effortlessly. To properly corner load a brush follow this procedure:

Step 1: Dip the corner of a clean brush which has been dampened with water into a puddle of paint.

Step 2: Move the brush to a clean spot on the palette and begin to make a series of short pull strokes *all in the same spot.*

Step 3: You will see the color graduate from strong, pure color to a lighter and lighter color until it is just clear water. Practice with a little larger brush until you really understand the technique. Study the series of photos.

Double Loading:

When you double load, you will dip both corners of the brush into different colors of paint and blend as described in corner loading.

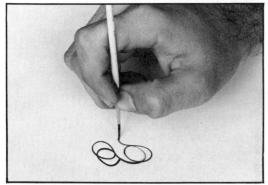

Scrolls painted with a liner brush

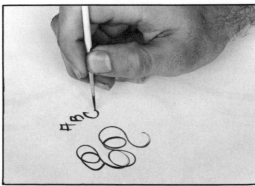

Lettering line work with thin consistency

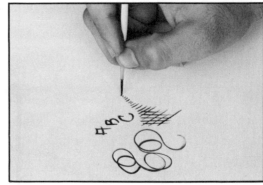

Line work with the brush in vertical position

Line Work:

Line work is accomplished with your Liner or Scroll brush and paint that is a very thin, ink-like consistency. When you load your brush, twist and drag it to form a point. Hold the brush with the handle pointing toward the ceiling and use a light touch!

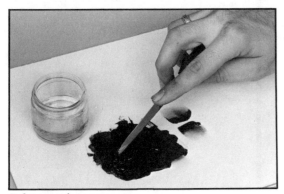

Tube consistency

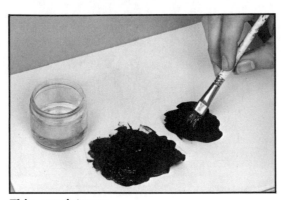

Thin consistency

Wash consistency

Proper Paint Consistency:

Tube consistency: Paint just as it comes from the tube, thick and creamy (often referred to as creamy or thick creamy).

Thin consistency: With a wet brush, drag some paint away from the pile and "brush mix" it until it has a uniform consistency. This consistency is used for brush strokes and striping.

Wash consistency: Thin paint with clean water until it is transparent. This is used to shade dry base coats or to tint an entire object.

Tips:

Always squeeze out a "healthy" amount of paint. A good size puddle of paint will not dry out as quickly as a small puddle will. Also, if a skin forms on a puddle of paint sometimes you will be able to pull it off and the paint underneath will still be quite moist, ready to use. You can also squeeze your paint out onto a damp paper towel and this too will slow the drying process.

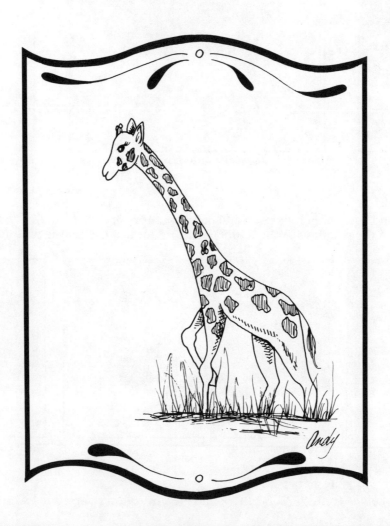

Basic Brush Strokes

Basic Brush Strokes

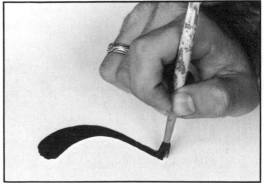

1. Comma stroke - Round brush 2. 3.

Comma Strokes with the Round brush:

Step 1: To paint a comma stroke angled to the right, fill a #3 Round brush with thin consistency paint.

Step 2: Angle the brush to the eleven o'clock position and touch, apply pressure, and almost allow the ferrule to touch the surface.

Step 3: Then, begin to lift and drag the brush to form a point.

Your key phrase is "touch, press, lift, and drag". Think of painting around an imaginary "C". Always lean to the inside of a stroke.

To paint a comma angled to the left, simply reverse the description above.

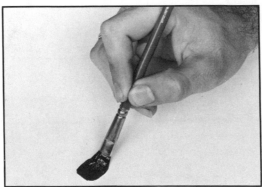

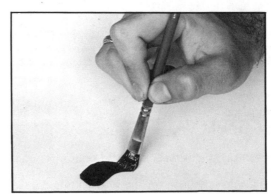

1. Comma stroke - Flat brush 2.

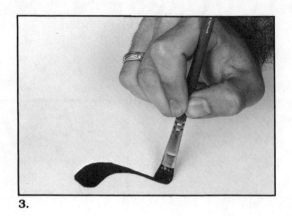

3.

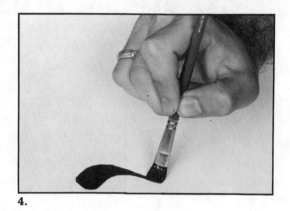

4.

Flat brush Strokes:

Commas with a Flat brush:

 Step 1: Load a Flat brush with thin consistency paint.

 Step 2: Angle the brush to the corner of the surface, then touch the brush down, apply pressure, and then begin to lift back up on the chisel edge. The comma strokes should have a fat head and a skinny tail.

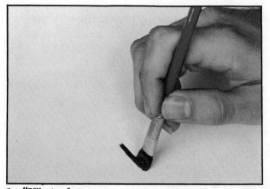

1. "U" stroke

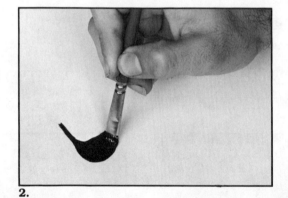

2.

3.

"U" Strokes:

 Step 1: Load a Flat brush with thin consistency paint.

 Step 2: Stand the brush on the chisel edge and begin to pull toward yourself, forming a line stroke.

 Step 3: Now, begin to apply pressure on the Flat brush, curving the stroke movement.

 Step 4: Begin to lift back up on the chisel edge to form a line stroke. Study the series of photos.

1. "S" strokes 2. 3.

"S" Strokes:

Step 1: Load a Flat brush with thin consistency paint.

Step 2: Stand the brush on the chisel edge and begin to slide the brush toward yourself.

Step 3: As you are pulling, begin to apply pressure to the flat surface of the brush.

Step 4: Begin to lift back up on the chisel edge and drag. Study the series of photographs.

Your key phrase is "slide, press, lift, and slide".

Please, please practice and learn these important brush strokes because they will make your painting much easier and faster. Don't worry if your first attempts are a bit shaky. I promise that with practice you will learn brush strokes and have so much fun doing them!

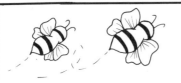 **BEE EXACT**

Preparation of Surfaces

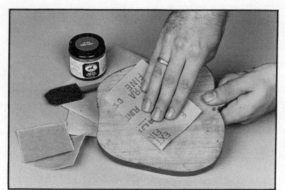

Lightly sand surface

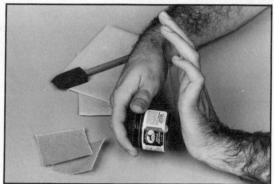

Thoroughly shake base coat acrylic

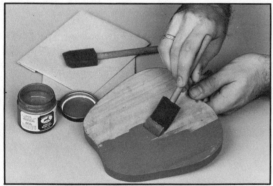

Apply base coat acrylic

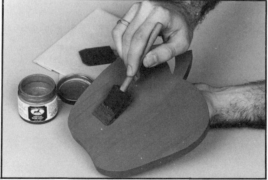

Apply second coat

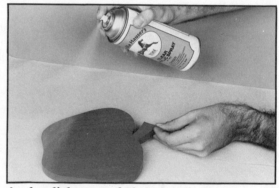

Apply a light coat of Clear Acrylic Spray

Painted Background:

If the entire surface of the board is to be painted with various base coat acrylics, use the following procedure.

Step 1: Lightly sand to remove any very rough areas.

Step 2: Using a sponge brush, apply a thin coat of base coat acrylic. Allow this to dry completely.

Step 3: Sand the plaque. Now you are thinking, "but I've already sanded" and yes, you have, but a second sanding is needed. The first coat of acrylic acts as a wood sealer and raises the grain so now you must sand to smooth the grain.

Step 4: Apply a second coat of your base coat acrylic. Let dry.

Step 5: Lightly mist the plaque with ph Clear Acrylic Spray. This does not mean to gun the spray nozzle and put a heavy coat on the board, just *lightly* mist it three or four times.

Step 6: Transfer pattern and paint.

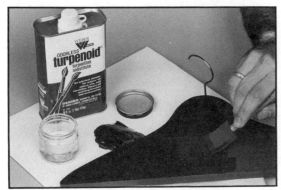
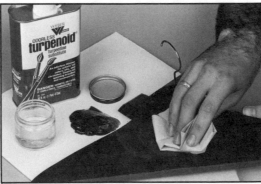
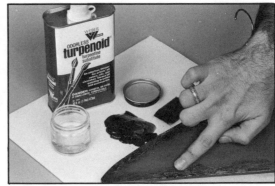

Apply stain mixture with sponge brush **Wipe off desired amount** **Darken edges with color if desired**

Stained Background:

To stain a board with oils use the following procedure.

Step 1: With a damp rag or sponge brush, wipe the surface of the board with Turpenoid..

Step 2: Thin Burnt Umber or the desired color down to a thin, creamy consistency with Turpenoid and brush it on with a sponge brush.

Step 3: Quickly take a dry paper towel or soft rag and wipe the stain down. Let dry.

Step 4: Apply several coats of ph Clear Acrylic Spray to seal the board. Let dry.

Step 5: Take a piece of brown grocery sack and begin to "sand" or smooth the grain of the wood.

Trace design onto a sheet of Transpalette **Chalk over design lines on back side**

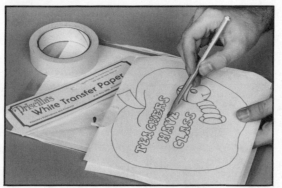

Trace over lines with a medium touch

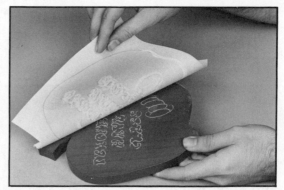

Check to see how pattern is transferring

Pattern Transfer:

First, select the design you want to paint, then lay a piece of Transpalette over the pattern and trace the design with a good black felt tip pen. You only need to trace the main outlines, no shading marks, veins in leaves, or curlicues. To transfer with chalk, turn the pattern over and mark over the lines with chalk. Do not scribble all over the back of the pattern, just on the lines. Now turn the right side up and tape the pattern into position, retrace the lines and when you lift off the paper you will see your pattern beautifully transferred to the surface.

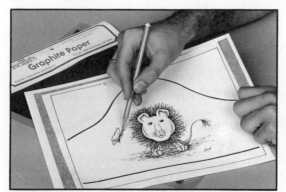

Trace over design with graphite paper underneath

Check to see how pattern is transferring

To transfer with graphite, trace your pattern and tape it into position, next you will slip your graphite paper underneath. (Always check to be sure the "right" side of the paper is down.) Now retrace the lines and you will see that your pattern is now on your prepared surface.

Study the photographs for they will help you better understand the process.

Finishing

Finishing:

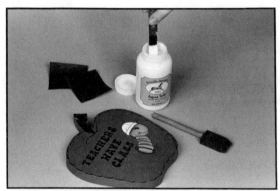

Stir Aqua Tole Finish

Dip sponge brush in finish

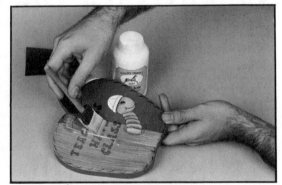

Apply finish in straight strokes

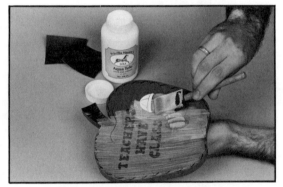

Coat entire surface with Aqua Tole

For most of the projects in this book, I have applied two or three coats of Aqua Tole Finish. Always apply this finish with a new, clean sponge brush or one that you save for this purpose. Sometimes a dirty sponge brush will leave a trace of color on your project. Remember to let each coat dry completely before applying another.

Projects

Mommie's Strawberries
Hoop Hoop Hurrah for Mushrooms
Country Cattails
Bright Tulips
Mallards for Dad
Lion and Blue
Spotty Giraffe
Buzzin' Bees
Wiggly Worm
Froggy Bathroom

Mommie's Strawberries

Mommie's Strawberries

The bright reds and greens make this an eye-catching set. It would look great at mom's kitchen desk or anywhere she needs a splash of color. Paint these pieces for Mother's Day — what a special surprise!

Materials:

Palette: Permalba Acrylics: Titanium White, Hookers Green, Napthol Crimson, Permanent Green Light, Cadmium Yellow Light, Burnt Sienna, Burnt Umber, Alizarin Crimson, Mars Black, and Acrylic Gel Medium.

Brushes: #1 Liner or Scroll, #4 Flat Acrytole, #6 Flat Acrytole, and #8 Flat Acrytole brushes.

Miscellaneous Items: ph Clear Acrylic Spray.

Preparation:

The only preparation necessary for this particular desk set was a light misting of ph Clear Acrylic Spray to seal. Transfer pattern with chalk.

Painting Instructions:

Leaves:

Step 1: Base coat all leaves with Hookers Green. If one coat does not cover, apply a second coat. Let dry.

Step 2: Corner load a brush with Mars Black on one side of the brush and water on the other side of the brush. Apply shading around the strawberries or where one leaf goes under another leaf.

Step 3: Brush a thin coat of Acrylic Gel Medium over the leaf.

Step 4: While this is still wet, gently stroke some Permanent Green Light onto the leaf. Do not go quite to the outside of the leaf, and do not come to the base or bottom of the leaf. Study **Diagram #1** and the example on the Color Worksheet. Let dry.

Step 5: With your Liner brush and thin consistency Permanent Green Light, pull a vein in the leaf. (A vein is always a curved line, it starts at the base and does not quite touch the end of the leaf.) Finish one leaf completely before going to the next one.

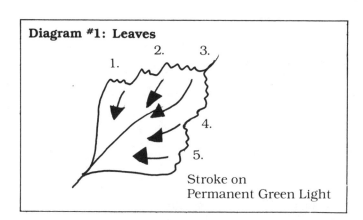

Diagram #1: Leaves

Stroke on
Permanent Green Light

Blossom Petals and Centers:

Step 1: Base coat the petals and center with Titanium White. Let dry. Apply a second coat if necessary.

Step 2: Corner load a #4 Flat brush with Cadmium Yellow Light on one side and water on the other side.

Step 3: Shade petals next to the center as shown in **Diagram #2**. Let dry.

Step 4: Corner load a small Flat brush with Burnt Umber on one side and water on the other side.

Step 5: Pat a *little* shading next to the center as shown in **Diagram #3**. Let dry.

Step 6: Paint the center with several coats of Cadmium Yellow Medium letting each coat dry completely before applying the next. Let dry.

Step 7: Apply a light wash of Burnt Sienna to the entire center. Let dry.

Step 8: Shade where the petals or centers of the blossoms go underneath a leaf or strawberry with a corner loaded brush of Burnt Umber.

Step 9: Using your Liner brush and thin consistency Burnt Umber, apply dots around the center. Let dry.

Strawberries:

Step 1: Apply a highlight of Titanium White to the center of the berry. Wipe out your brush. Feather the color out towards the edge. Your highlight should not go quite to the outside edge of the berry. Let this dry. Study **Diagram #4** and the example on the Color Worksheet.

Step 2: Apply a thin coat of Acrylic Gel Medium to the entire berry. While this is wet, corner load a Flat brush with Napthol Crimson and brush this in from the edge. You should still have a nice white highlight in the center of the berry. Let dry.

Step 3: Repeat Step 2 and let paint dry.

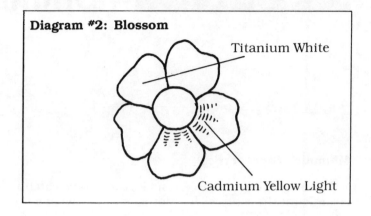
Diagram #2: Blossom
Titanium White
Cadmium Yellow Light

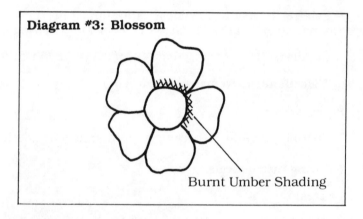
Diagram #3: Blossom
Burnt Umber Shading

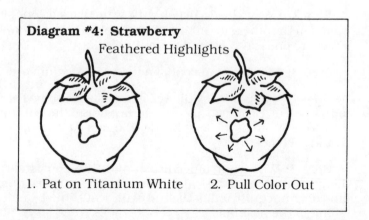
Diagram #4: Strawberry
Feathered Highlights
1. Pat on Titanium White 2. Pull Color Out

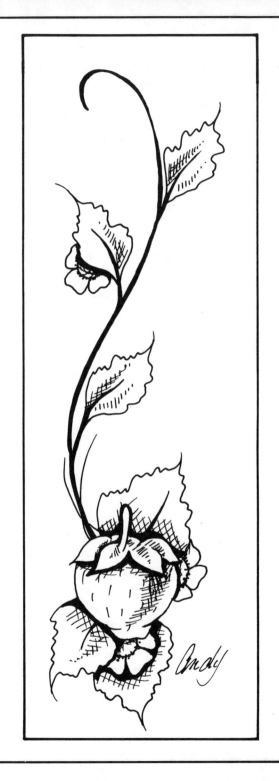

Step 4: Corner load a Flat brush with Alizarin Crimson and shade as illustrated in **Diagram #5**. Let dry.

Step 5: Corner load a Flat brush with Cadmium Red Light on one side and water on the other side: highlight the right or light side of the berry as illustrated in **Diagram #5**.

Step 6: Using your Liner brush and thin Cadmium Yellow Light, apply dots or seeds to your berry. Then place a fine black line next to the seed using your Liner brush and thin consistency Black paint. See **Diagram #6**.

Strawberry Bracts:

Step 1: Using a #3 or #6 Flat brush, base coat the bracts with Hookers Green. Let dry.

Step 2: Highlight the bracts with a little Permanent Green Light on a corner loaded brush.

Stems:

Stems are neatly painted with Hookers Green using your Liner or Scroll brush.

Finishing:

On this particular desk set, I did not use Aqua Tole Waterbase Varnish, but instead applied several coats of ph Clear Acrylic Spray. Be sure to protect the paper in the blotter with newspaper before spraying.

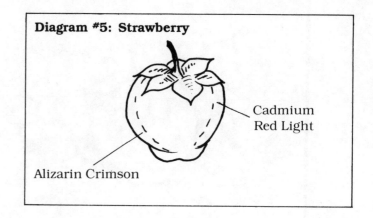

Diagram #5: Strawberry

Cadmium Red Light

Alizarin Crimson

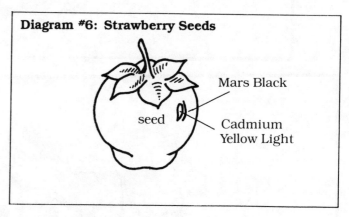

Diagram #6: Strawberry Seeds

Mars Black

seed

Cadmium Yellow Light

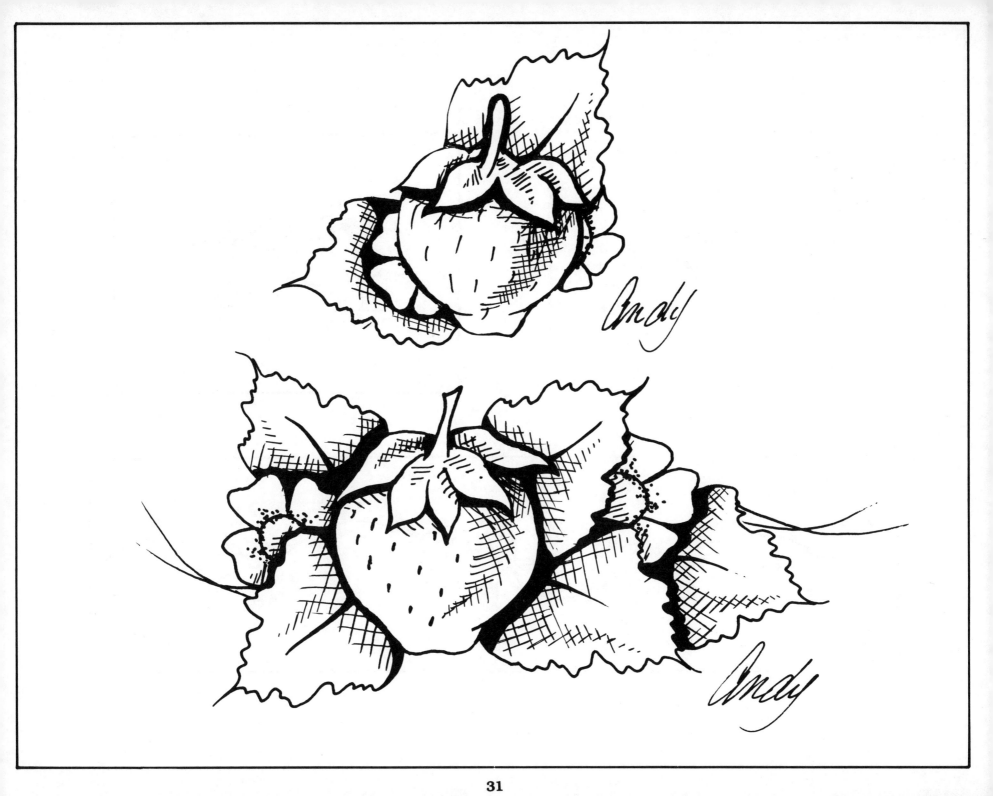

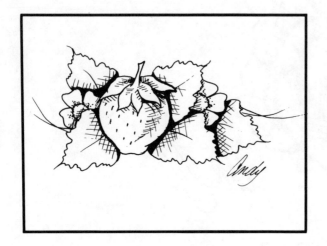

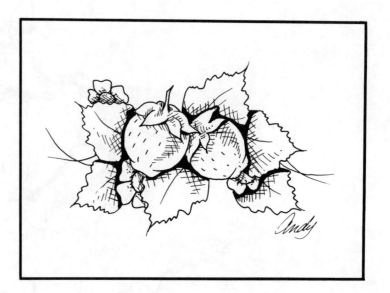

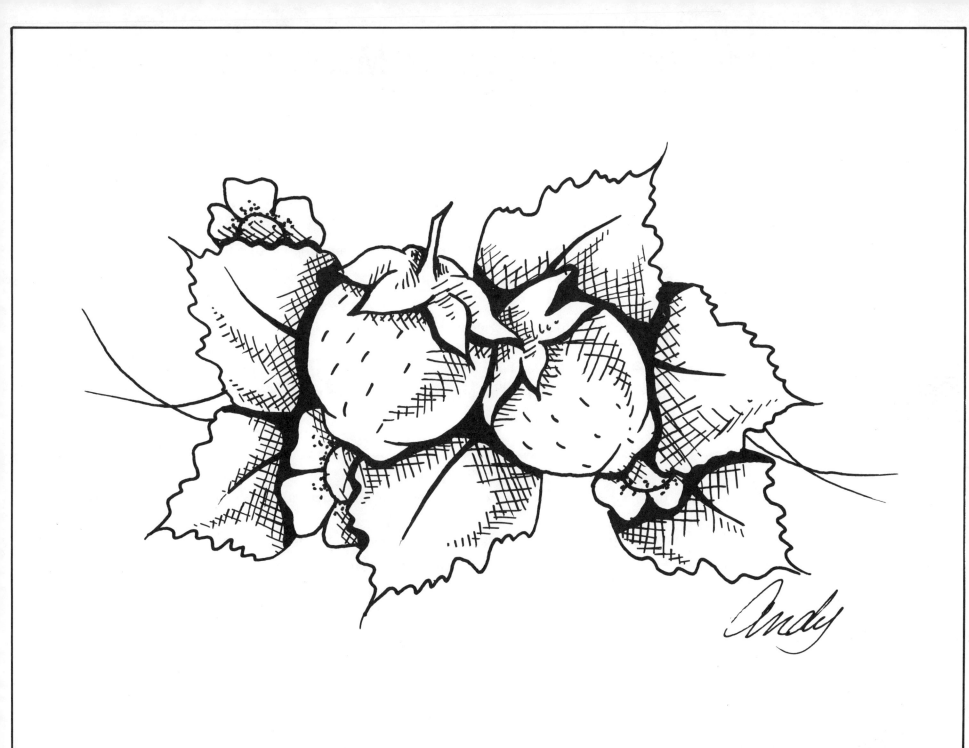

Hoop Hoop Hurrah for Mushrooms

Hoop Hoop Hurrah for Mushrooms

I think these little hoops are just as cute as can be. They will make darling wall decorations or jar lids. Do not limit your mushroom painting to hoops, you can paint them on a miniature canvas, a plaque, or a small box.

Materials:

Palette: Permalba Acrylics: Permalba White, Alizarin Crimson, Cadmium Yellow Light, Burnt Sienna, Bright Red, Cadmium Red Light, Hookers Green, Burnt Umber, and Mars Black.

Brushes: #4, #6, and #8 Flat Acrytole brushes and #1 Acrytole Liner brush.

Miscellaneous Items: 3″ Wooden Embroidery Hoop, shade cloth (or any thin, fine canvas), ph Base Coat Acrylic Leaf Green, White craft glue, and scissors.

Preparation:

Step 1: Cut a square of shade cloth two inches larger than your hoop.

Step 2: Separate the hoop and place the shade cloth between the two rings. Now clamp the two rings together and this will form a crease in the shade cloth.

Step 3: Remove the shade cloth from between the two rings and apply the glue to the outside of the inner hoop.

Step 4: Place the creased shade cloth back between the two rings and clamp them together. Pull the shade cloth taut in the hoop, then begin to tighten the screw at the top of the hoop.

Step 5: Let the glue dry for about 45 minutes. Now trim the excess shade cloth from the back of the hoop with scissors.

Step 6: Transfer pattern with Gray Graphite. Be careful not to press too hard or you could stretch the shade cloth.

Step 7: Remove the outer hoop and paint it with ph Base Coat Acrylic Leaf Green. Let dry and sand. Then apply a second coat.

Painting Instructions:

Step 1: Base coat the mushroom caps with Bright Red using your #6 Flat brush. If one coat does not cover, allow the first coat to dry and then apply a second coat.

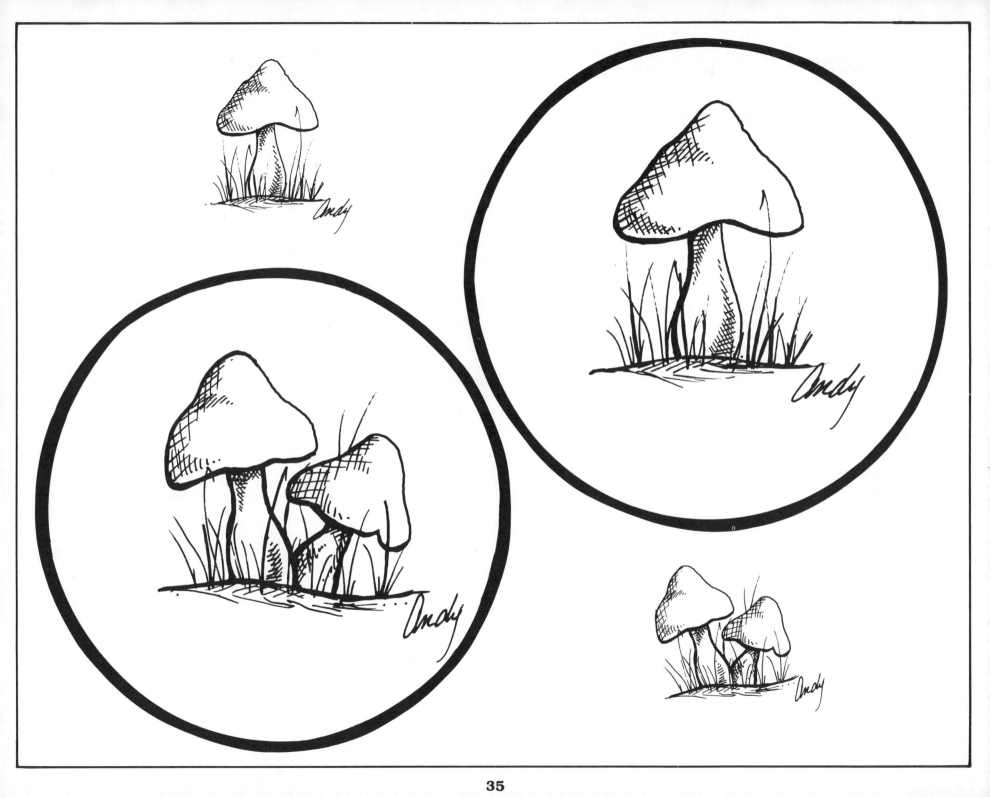

Step 2: Mix a dark shading red by mixing a small amount of Burnt Sienna into some Alizarin Crimson. Now corner load your #6 Flat brush with the shading red on one half of the brush and water on the other half. Apply the shading as shown in **Diagram #1** and on the Color Worksheet.

Step 3: To highlight the mushroom cap, we will corner load a #8 Flat brush with Cadmium Orange on one half of the brush and water on the other half and highlight along the right or light side. Study the Color Worksheet and **Diagram #2**.

Step 4: Base coat the stems with several coats of Titanium White. Allow each coat to dry before applying another.

Step 5: Using a #4 Flat brush, corner load with Burnt Umber on one half and water on the other half and shade where the stem joins the cap and at the ground area. Refer to **Diagram #3**.

Step 6: To paint the grass, apply Hookers Green in a "scruffy" manner. While this is still wet, brush in a little Cadmium Yellow Light with a #4 Flat brush. Refer to **Diagram #4**.

Step 7: Corner load a #6 Flat brush with Mars Black on one half of the brush and water on the other half and apply the Black along the top of the clump.

Step 8: With ink like paint, you will begin to pull sprigs of grass with your Liner brush. The colors that you will use are: Hookers Green, Mars Black, Burnt Umber, and a little Cadmium Yellow Light. Refer to **Diagram #5**.

Finishing:

To finish these darling hoops, I glued a piece of eyelet to the back of the hoop and tied a tiny satin bow at the tip of each hoop. Now they are ready to display in your kitchen.

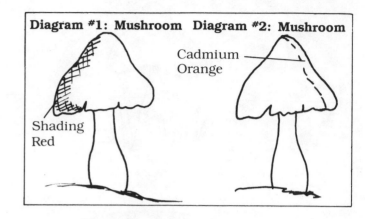

Diagram #1: Mushroom Diagram #2: Mushroom
Cadmium Orange
Shading Red

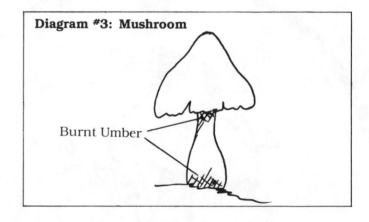

Diagram #3: Mushroom
Burnt Umber

Diagram #4: Grass
Cadmium Yellow Light
Hookers Green

Diagram #5: Grass
"Clumps of Grass"

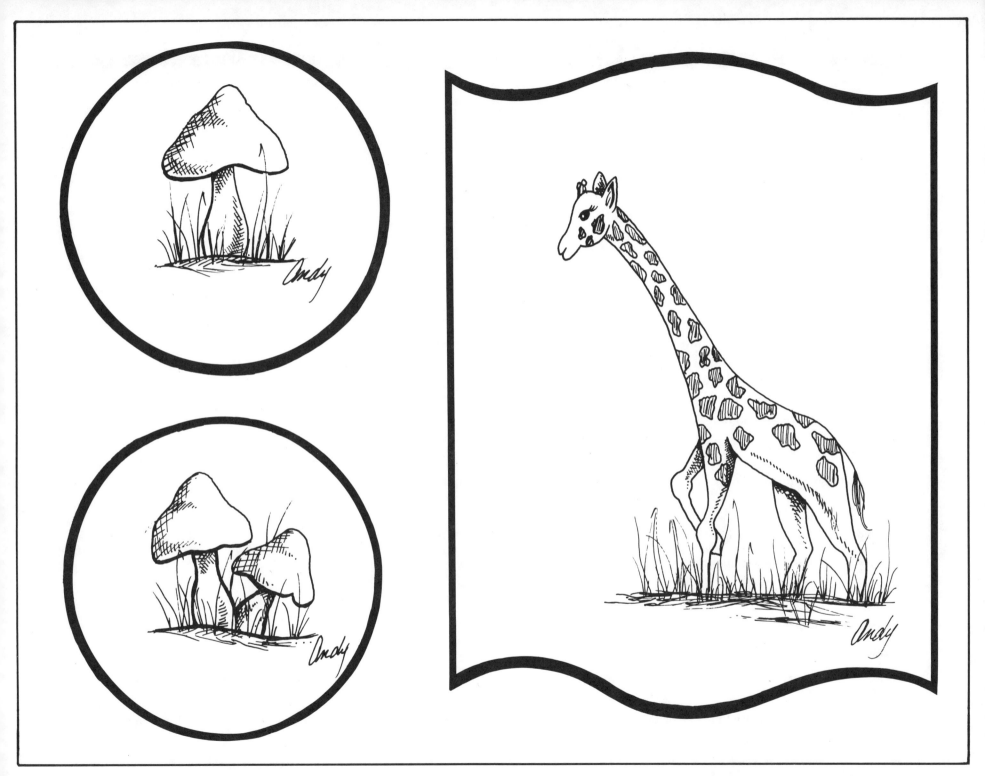

Country Cattails

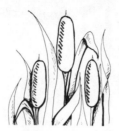

Country Cattails

Are you looking for something unusual to paint for your father, brother, uncle, or your favorite grandad? Then try these cattails on a handsome box that can be used on a dresser or desk.

Materials:

Palette: Permalba Acrylics: Titanium White, Cadmium Yellow Light, Mars Black, Burnt Sienna, Burnt Umber, Cadmium Red Light, and Acrylic Gel Medium.

Brushes: #1 Liner or Scroll, and #6 and #8 Flat Acrytole brushes.

Miscellaneous Items: old toothbrush, ph Clear Acrylic Spray, ph Base Coat Acrylic Malibu and Autumn Rust, and Chalk.

Preparation:

Step 1: Base coat the lid of the box with Malibu. Base coat the bottom of the box with Autumn Rust.

Step 2: Mist with several light coats of ph Clear Acrylic Spray.

Step 3: We will now flyspeck the project. To flyspeck, dip an old toothbrush in thin, ink like Burnt Umber. With the bristles pointing down, pull your thumb over the bristles and you will notice many tiny specks of paint fall on the surface of the box. I would recommend that you practice on a piece of newspaper before actually speckling the box. Let dry.

Step 4: Transfer pattern with chalk.

Painting Instructions:

Cattail Blades:

Step 1: Base coat all of the blades with a mixture of Cadmium Yellow Medium to which you have added a healthy touch of Mars Black. Use your #6 Flat brush. Let dry.

Step 2: Shade the blades where one blade goes behind the other blade or behind a cattail. Use a corner loaded brush of Mars Black on one side and water on the other side. Allow to dry completely. Study the example on the Color Worksheet.

Step 3: Highlight the blades with a mixture of Cadmium Yellow Medium plus Mars Black. Study the Color Worksheet and the photograph of the finished piece.

Cattails:

Step 1: Base coat the cattails with Burnt Sienna; let dry and apply a second coat if necessary.

Step 2: Brush a thin coat of Acrylic Gel Medium on the cattails and while this is still wet, corner load a #6 Flat brush with Burnt Umber and shade the left or dark side of the cattail.

Step 3: Brush a thin coat of Acrylic Gel Medium over the entire cattail and while this is still wet, corner load a #6 Flat brush with Cadmium Red Light and shade the right or light side of the cattail.

If you study the finished sample, you will notice that some of the cattails are darker and some are much lighter. To do this simply add more dark shading to some and more highlight to others. This gives you CONTRAST which makes your decorative painting really beautiful and exciting.

Stroke Design:

Step 1: Paint the entire design very neatly and carefully with thin consistency Burnt Umber using your Liner brush. Let dry.

Step 2: Overstroke some of the comma strokes with Malibu.

Finishing:

Finish with several coats of Aqua Tole Waterbase Varnish.

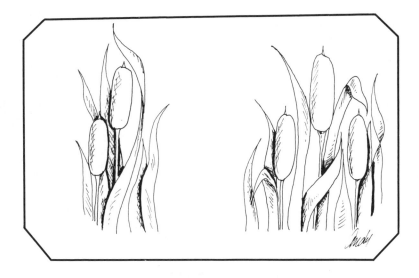

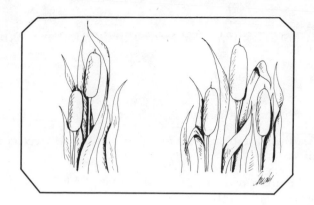

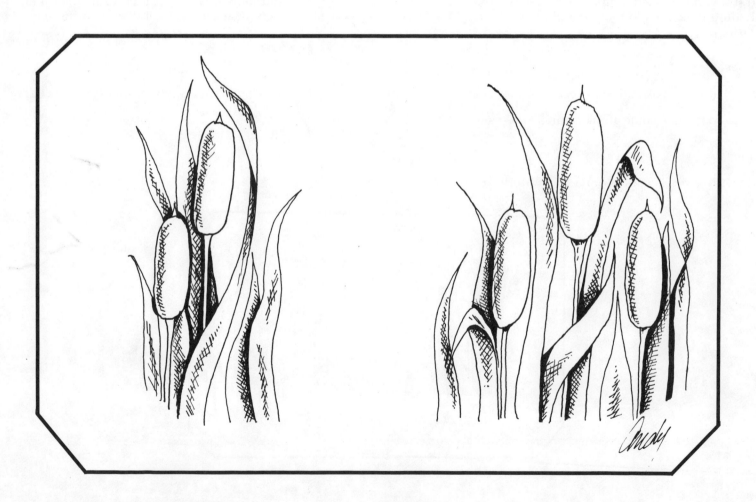

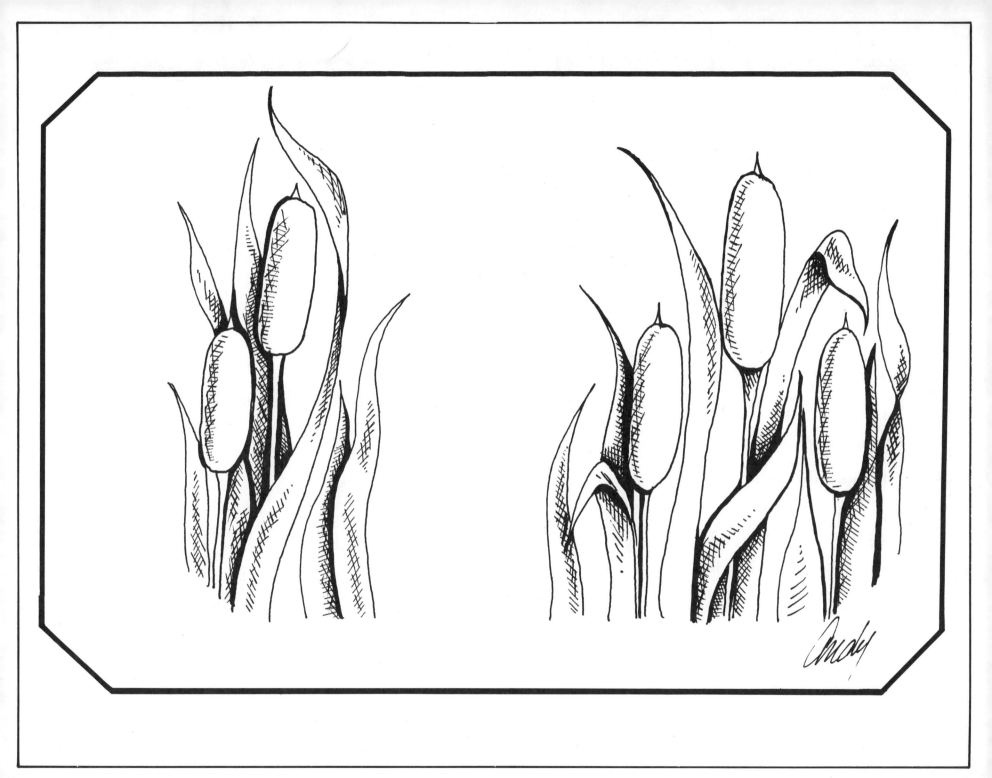

Bright Tulips

Bright Tulips

Soft and delicate tulips will be ideal painted on mom's jewelry box. Tulips can be done in many colors. Match the colors used in mom's bedroom or powder room. This simple gift will surely dazzle her eye.

Materials:

Palette: Permalba Acrylics: Chrome Oxide Green, Mars Black, Napthol Crimson, Titanium White, Alizarin Crimson, and Acrylic Gel Medium.

Brushes: #4, #8, and #10 Flat Acrytole brushes.

Miscellaneous Items: old toothbrush, ph Clear Acrylic Spray, ph Base Coat Acrylic Malibu and Deep Forest.

Preparation:

Step 1: Base coat the lid of the box with Malibu. Base coat the bottom of the box with Deep Forest.

Step 2: Mist with several light coats of ph Clear Acrylic Spray.

Step 3: We will now flyspeck the project. To flyspeck, dip an old toothbrush in thin, ink like consistency Chrome Oxide Green. With the bristles pointing down, pull your thumb over the bristles and you will notice many tiny specks of paint fall on the surface of the box. I would recommend that you practice on a piece of newspaper before actually speckling the box. Let dry.

Step 4: Transfer pattern to surface.

Painting Instructions:

Tulip Blades:

Step 1: Base coat all of the blades with a mixture of Chrome Oxide Green and Black. Use your #8 Flat brush.

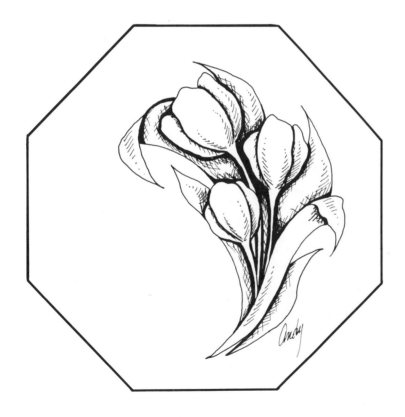

Step 2: Shade the blades where one blade goes behind the other blade or behind a tulip. Use a corner loaded brush of Mars Black on one side and water on the other side. Allow to dry completely. Study the example on the Color Worksheet.

Step 3: Highlight the blades with a mixture of Chrome Oxide Green plus Titanium White. Study the Color Worksheet.

Tulips:

Step 1: Base coat the tulips with a mixture of Napthol Crimson plus Titanium White. Let dry.

Step 2: Brush a thin coat of Acrylic Gel Medium on the tulip side petals and while this is still wet, corner load a #8 Flat brush with a mixture of Napthol Crimson plus Alizarin Crimson. Apply this color next to the large center petal on both sides. See Color Worksheet.

Step 3: Brush a thin coat of Acrylic Gel Medium over the entire center tulip petal and while this is still wet, corner load a #10 Flat brush with the dark shading pink on lower part of petal and blend into gel.

Stroke Design:

Step 1: Paint the entire design very neatly and carefully with thin consistency Malibu Acrylic Base Coat.

Step 2: Dots are also applied with Malibu.

Finishing:

Finish with several coats of Aqua Tole Waterbase Varnish.

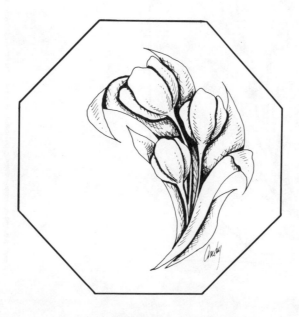

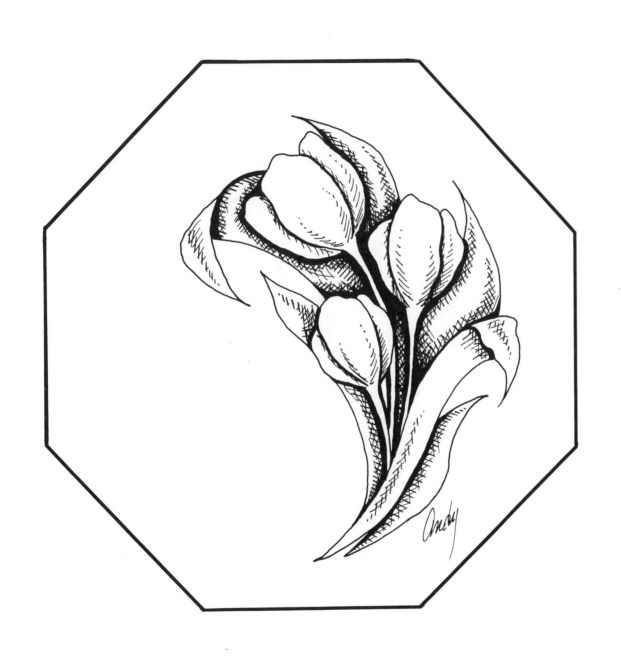

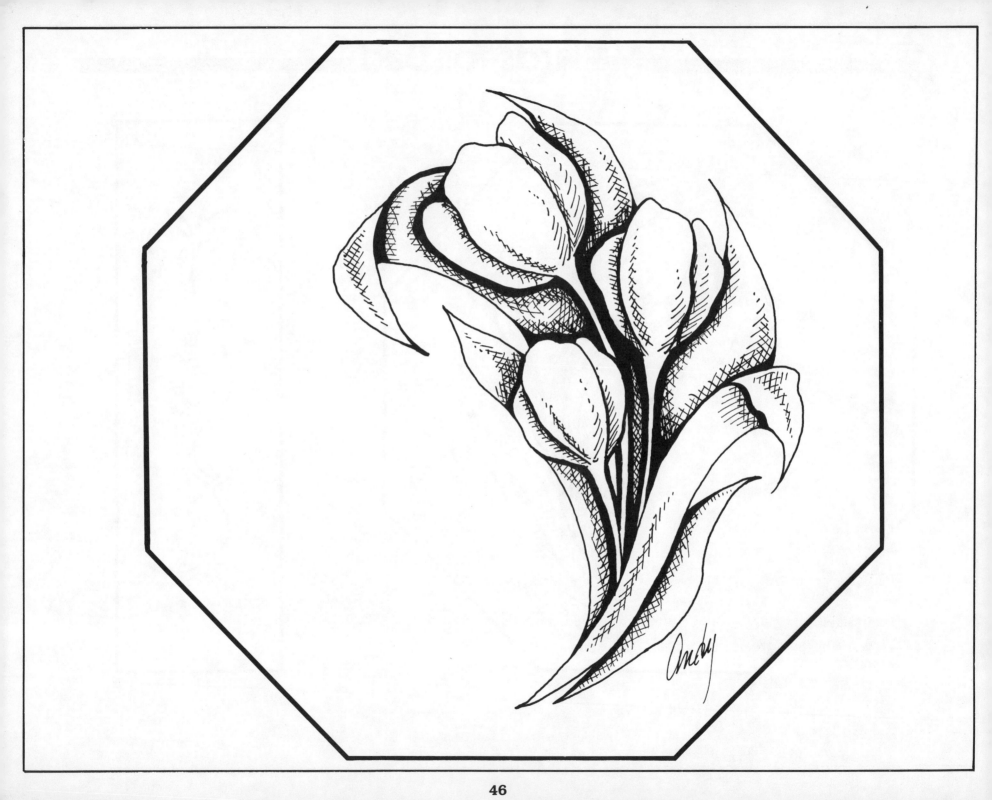

Mallards for Dad

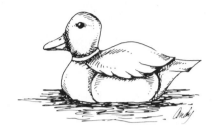

Mallards for Dad

Here is something for you to paint for dad. Try the striking mallard ducks on a letter and pencil holder. These ducks would also look great on a waste paper basket, a cigar box, or any number of other surfaces. Create a whole grouping for dad's desk in the den.

Materials:

Palette: Permalba Acrylics: Hookers Green, Permanent Green Light, Alizarin Crimson, Titanium White, Mars Black, Cadmium Yellow Light, Raw Umber, Burnt Sienna, Phthalo Blue, and Acrylic Gel Medium.

Brushes: #2, #4, and #6 or #8 Flat Acrytole brushes.

Preparation:

There was little preparation necessary on this particular desk set except for a light mist of ph Clear Acrylic Spray to seal.

Painting Instructions:

Base coat the duck as shown on the Color Worksheet using Titanium White.

Beak:

Step 1: Base coat the beak with Cadmium Yellow Light. Let dry and apply a second coat if necessary.

Step 2: Corner load a #2 or #4 Flat brush with Burnt Sienna and apply shading next to the face and along the bottom edges as shown on the Color Worksheet.

Step 3: Using your Liner brush and thin Burnt Sienna, paint a division line down the center of the beak. Let dry.

Step 4: Highlight the beak with Cadmium Yellow Light and White.

Head:

Step 1: Base coat the head with Hookers Green. Let dry and apply a second coat if necessary.

Step 2: Corner load a #6 Flat brush and shade the head with Mars Black next to the neck ring. Let dry.

Step 3: Double load a brush with Gel Medium and Permanent Green Light. Pat a highlight along the top of the head and on the cheek. Let dry. Repeat this step if necessary to emphasize the cheek.

Step 4: The eye is painted with Mars Black and highlighted with Titanium White.

Breast:

Step 1: Apply a wash of Alizarin Crimson to the breast area. Let dry. Strengthen the wash at the edges if necessary.

Step 2: Corner load a #8 Flat brush with Mars Black and shade the breast where it goes under the wing and where it meets the neck. Let dry.

Tail Section:

Step 1: Base coat the tail section with Phthalo Blue. Apply a second coat if necessary. Let dry.

Step 2: Corner load a #4 or #6 Flat brush with Mars Black and water and shade the tail where it joins the body. Let dry.

Step 3: Highlight the edges of the tail with a mixture of Phthalo Blue and White. Study the finished duck on the Color Worksheet.

Wing:

Step 1: Brush a thin coat of Acrylic Gel Medium onto the wing. While this is still wet, corner load a #8 Flat brush and apply shading along the duck's back. Let dry.

Step 2: Corner load a #8 Flat brush and shade next to the neck ring. Pat this shading out into the wing area. Let dry.

Side:

Step 1: Shade where the wing comes over the side of the duck with a corner loaded brush of Raw Umber and water.

Step 2: Brush a thin coat of Acrylic Gel Medium over the entire side and shade with a corner loaded brush of Raw Umber. Be sure to leave a nice light highlight in the center.

Water:

When you paint the water, you must work quickly because it must be done "wet in wet".

Step 1: Brush on a thin coat of Acrylic Gel Medium to the water area.

Step 2: While this is still wet, brush in some Phthalo Blue and feather the blue out.

Step 3: While the blue is wet, add a few highlights of Titanium White in a corner loaded brush. Study the water on the Color Worksheet and on the finished sample.

Finishing:

I sprayed several coats of ph Clear Acrylic Spray to finish these pieces.

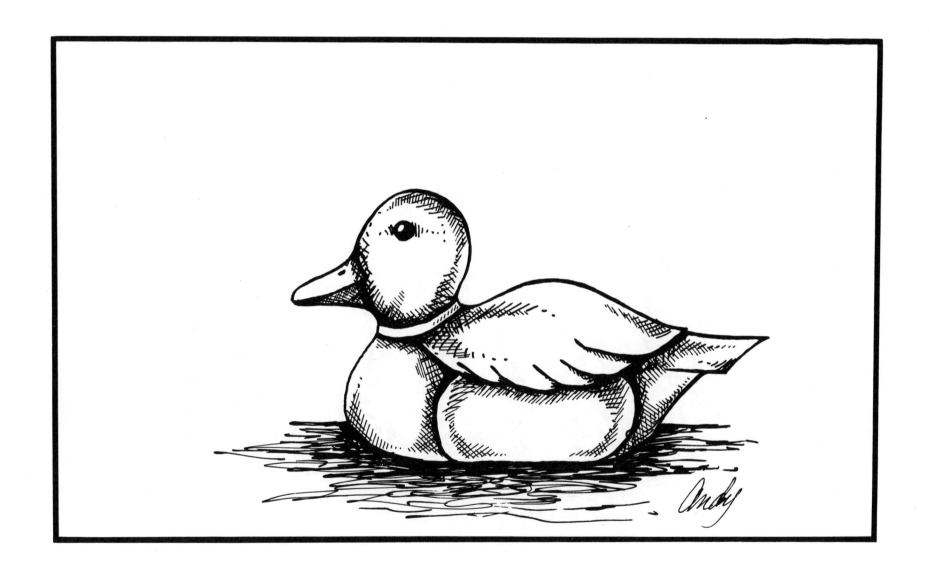

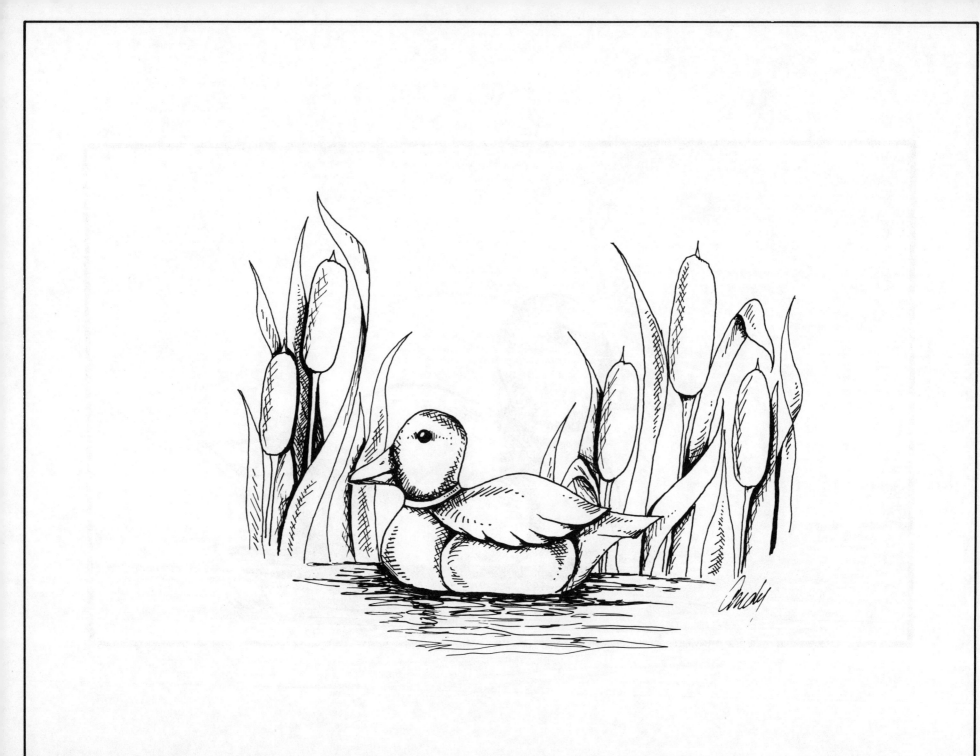

50

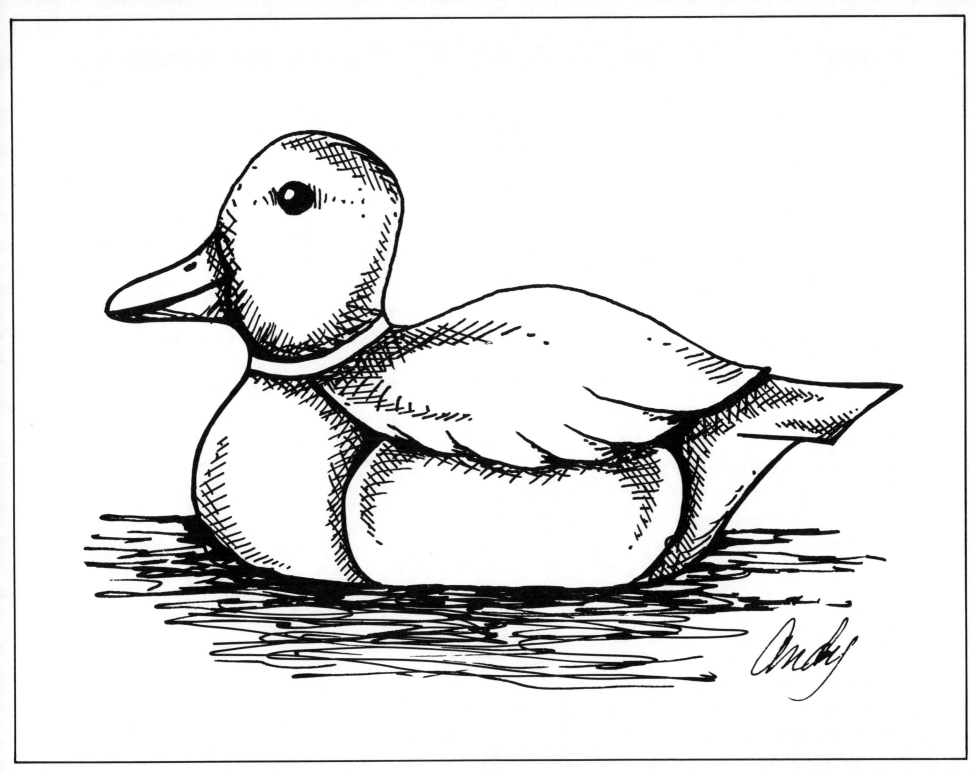

Lion and Blue

Lion and Blue for Priscilla

I think this is as cute as can be. This coat hanger was inspired by a book, *A Lion and Blue*, that Priscilla showed to me when I visited her in Tulsa, Oklahoma. If you should ever get the chance to read the book, do so.

Materials:

Palette: Permalba Acrylics: Titanium White, Cadmium Yellow Medium, Bright Red, Burnt Sienna, Burnt Umber, Mars Black, Cobalt Blue, and Phthalo Blue.

Brushes: #1 Liner or Scroll brush, #2, #4 and #8 Flat Acrytole brushes.

Preparation:

Step 1: Base coat the coat hanger with Yellow Ochre.

Step 2: Trim the edges with Burnt Sienna.

Step 3: Mist with several light coats of ph Clear Acrylic Spray. Let dry.

Step 4: Transfer pattern with chalk.

Painting Instructions:

"Blue":

Step 1: Base coat with Titanium White on the wings. Let dry.

Step 2: Paint the body with Burnt Umber. Let dry.

Step 3: Add a tiny White highlight to the head and body with thin paint using your Liner brush.

Step 4: Base coat the wings with Cobalt Blue. Apply a second coat if necessary.

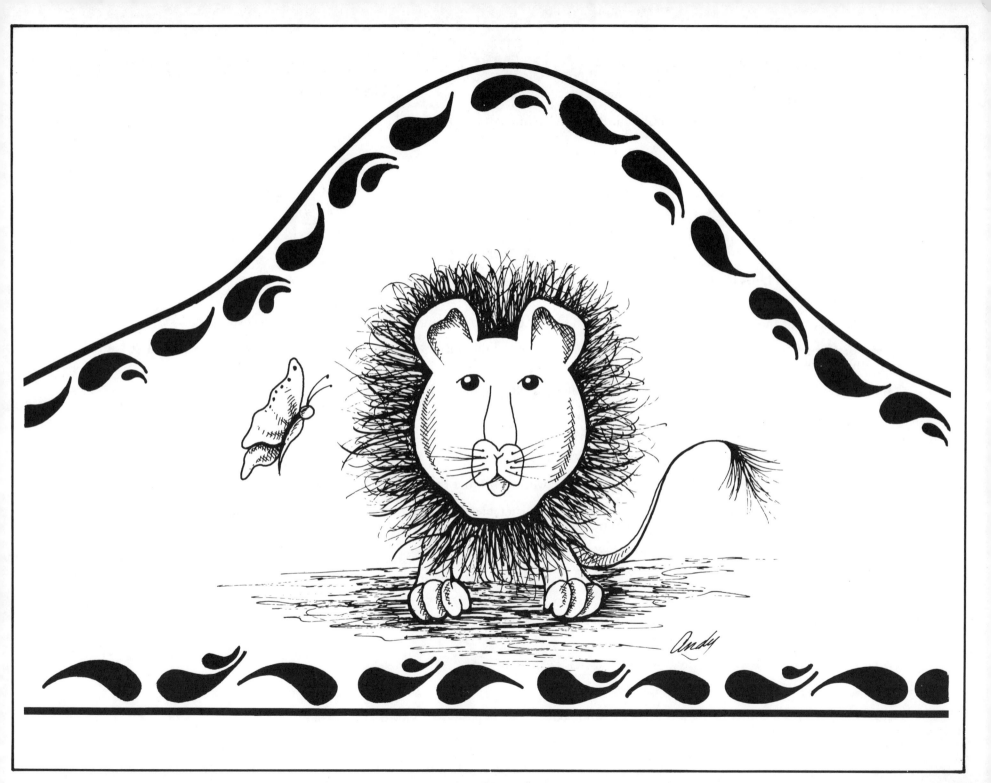

Step 5: Using a corner loaded brush with Phthalo Blue, shade the wings where they connect to the body. Refer to **Diagram #1**.

Step 6: Apply dots to the wings with thin Titanium White paint using your Liner brush.

Lion:

Step 1: Shade around the head of the lion with a corner loaded brush of Burnt Umber and water. Let dry.

Step 2: Using very thin paint, dab the following colors onto the mane area: Red Oxide, Burnt Sienna, Burnt Umber. Let dry. Study the Color Worksheet.

Step 3: Using your Liner brush and thin, ink like paint pull hairs of: Burnt Umber, Burnt Sienna, Red Oxide, and Cadmium Yellow Light.

Step 4: Base coat the face and paws of the lion with several coats of Cadmium Yellow Medium. Let dry.

Step 5: Corner load a #6 Flat brush with water on one side and Burnt Umber on the other side. Using a modified "U" stroke, create the ear folds.

Step 6: Eyes are painted with Mars Black and highlighted with Titanium White.

Step 7: Base coat the muzzle with Yellow Ochre. "Wisker holders" are dots of Burnt Umber. Using thin, ink like paint on your Liner brush, paint the wiskers with Burnt Sienna.

Step 8: Paint the tongue with a mixture of Bright Red and White.

Step 9: The lines that form the nose bridge are painted with your Liner brush and Yellow Ochre.

Step 10: The cheeks are painted with your #6 Flat brush. Corner load the brush with Napthol Crimson and water. Paint a quarter circle stroke, and then quickly brush the color out. Study the Color Worksheet.

Step 11: Outline paws with Burnt Umber using your Liner brush.

Step 12: Brush a thin coat of Acrylic Gel Medium over the ground area and while this is wet, brush in a little Burnt Umber and feather it away.

Step 13: Neatly and carefully paint the border of comma strokes with Burnt Umber.

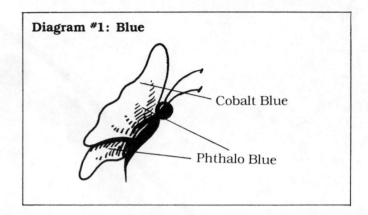

Diagram #1: Blue

Cobalt Blue

Phthalo Blue

Spotty Giraffe

Giraffe

If you have ever been to a zoo, then surely you remember the tall and graceful giraffe. Bring back happy memories of the day at the zoo with a giraffe on a switchplate for your family member or best friend's bedroom.

Materials:

Palette: Permalba Acrylics: Titanium White, Yellow Ochre, Cadmium Yellow Light, Burnt Umber, Hookers Green, Mars Black, and Burnt Sienna.

Brushes: #2 and #4 Flat Acrytole brushes.

Miscellaneous Items: ph Base Coat Acrylic Coco.

Preparation:

Step 1: Base coat the switchplate with Coco brushing acrylic.

Step 2: Trim the edge with Yellow Ochre.

Step 3: Mist with ph Clear Acrylic Spray.

Step 4: Transfer pattern with chalk.

Painting Instructions:

Step 1: Base coat the giraffe with White acrylic. Let dry. Apply a second coat if necessary.

Step 2: Base coat the giraffe with a mixture of Titanium White to which you have added a touch of Yellow Ochre and a touch of Cadmium Yellow Light. Let dry.

Step 3: Retransfer the spots to the giraffe.

Step 4: Apply a wash of Cadmium Yellow Light to a couple of places on the giraffe. Let dry.

Step 5: Shade the giraffe with Burnt Sienna on a corner loaded #2 or #4 Flat brush as shown on the Color Worksheet.

Step 6: Using your Liner brush and creamy paint, paint the spots on the giraffe. If one coat does not cover, then let them dry and carefully apply a second coat.

Step 7: The eye is painted with Mars Black and has a Titanium White highlight.

Step 8: The hooves are painted with Mars Black and have a White highlight.

Grass:

Step 1: Apply Hookers Green in a scruffy manner. While this is still wet, brush in a little Cadmium Yellow Light as shown on the Color Worksheet and on the Mushroom Worksheet.

Step 2: Corner load a small Flat brush with Mars Black and shade along the top of the clump and let this dry.

Step 3: Using your Liner brush and thin, ink like paint, pull strokes of grass in Hookers Green, Black, and a mixture of Hookers Green and Cadmium Yellow Light.

Finishing:

A name can be added to personalize this nameplate. On this particular switchplate, the name was painted in Yellow Ochre with the Liner brush. Be as neat as you can be! Finish with several coats of Aqua Tole Waterbase Varnish.

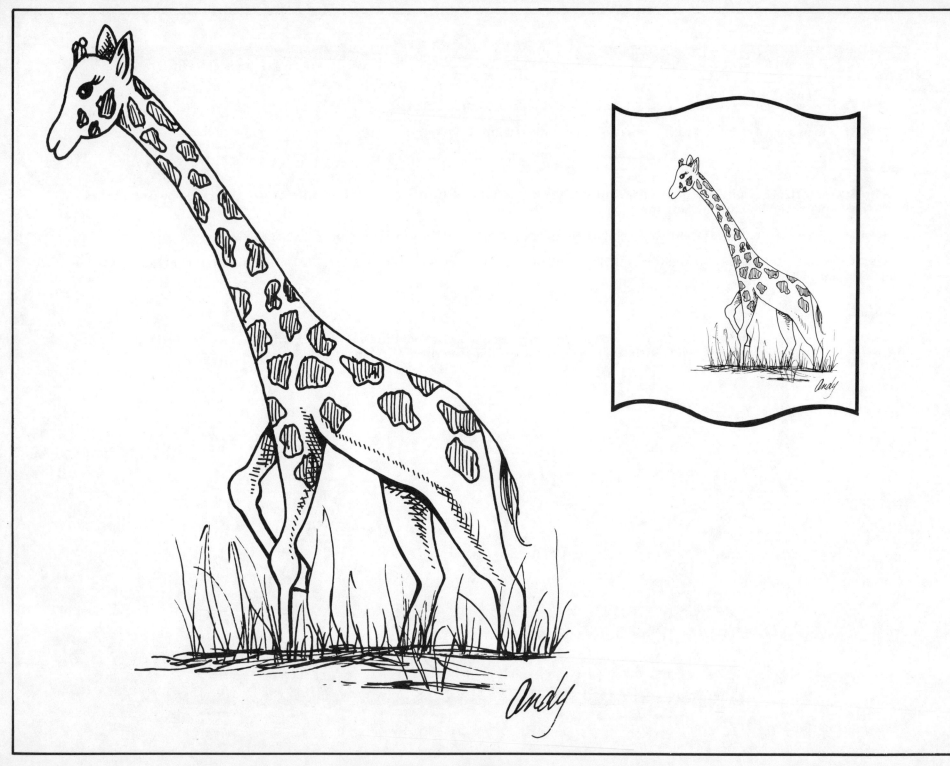

Buzzin' Bees

BEE EXACT

Buzzin' Bees

Wouldn't a teacher be delighted with these darling bees painted on a set of desk accessories — you'll love doing them, they are so easy to paint.

Materials:

Palette: Permalba Acrylics: Titanium White, Cadmium Yellow Light, Mars Black, and Acrylic Gel Medium.

Brushes: #3 and #4 Flat Acrytole, #3 Round Acrytole, and #1 Liner or Scroll brush.

Preparation:

Step 1: Stain the wooden surface with Burnt Umber Acrylic which has been thinned with water. Let dry.

Step 2: Lightly seal the surfaces with ph Clear Acrylic Spray or a coat of ph Aqua Tole Waterbase Varnish.

Step 3: Transfer pattern with chalk.

Painting Instructions:

Bees:

Step 1: Base coat the body of the bees with Titanium White. Let dry and apply a second or third coat if needed.

Step 2: Base coat the body with Cadmium Yellow Medium. Let dry and apply a second coat if needed.

Step 3: Paint the stripes on the bees with creamy Black paint using your Liner brush.

Step 4: Outline the body of the bees with thin paint using your Liner brush.

Step 5: Base the wings with Acrylic Gel Medium. While this is still wet, corner load a brush with white and highlight the edges of the wings. The paint should be transparent. Study the Color Worksheet for a better understanding of this technique.

Step 6: With ink like Titanium White paint on your Liner brush, paint several thin, hair-like lines on the wings.

Step 7: Antennae are painted with Mars Black and your Liner brush.

Lettering or border:

Paint the large comma strokes with Red Hot Base Coat Acrylic with your #3 Round brush. Dots are Cadmium Yellow Medium. Letters are Red Hot.

Finishing:

Finish pieces with several light coats of Aqua Tole Waterbase Varnish.

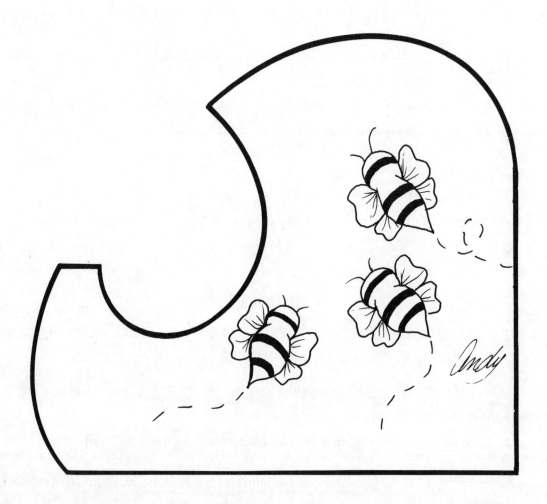

 BEE EXACT *Andy*

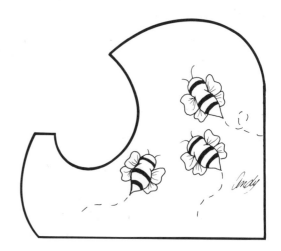

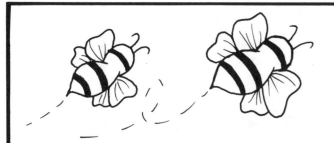 **BEE EX**

EE EXACT *Andy*

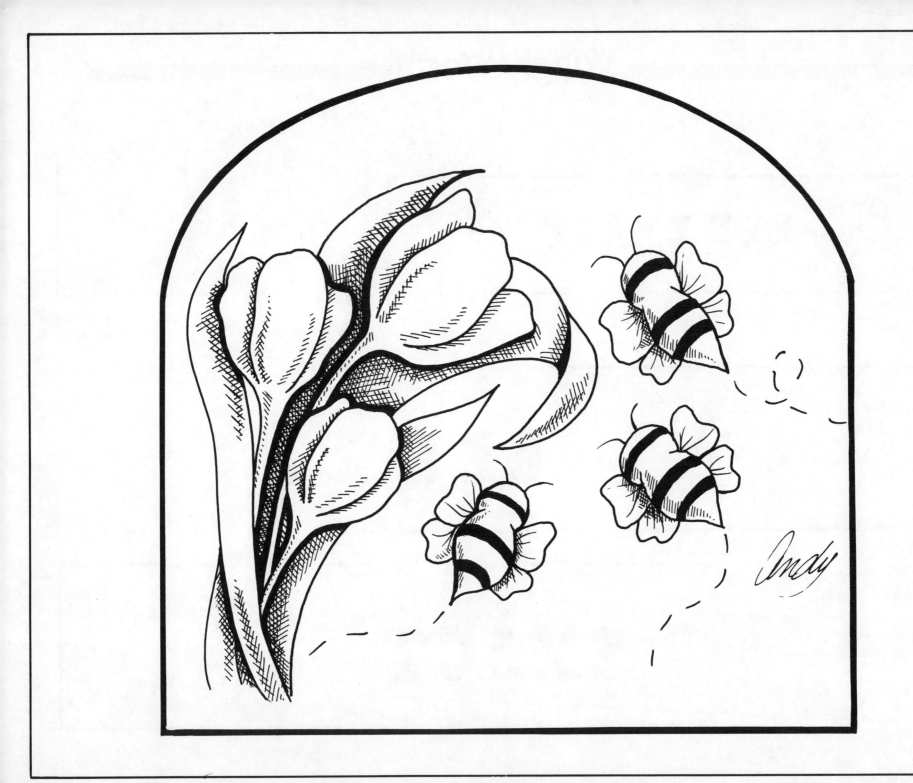

Wiggly Worm

Wiggly Worm

If you are in need of a gift for your teacher — try painting this little worm in the apple plaque. The worm pencil and crayon holder is ideal to paint for your brother or sister.

Materials:

Palette: Permalba Acrylics: Titanium White, Cadmium Yellow Light, Cerulean Blue, Hookers Green, Burnt Sienna, Mars Black, and Napthol Red Light.

Brushes: #1 Liner brush, #4, #6 and #8 Flat Acrytole brushes.

Preparation:

Step 1: Base coat the plaque with Red Hot Acrylic.

Step 2: Mist the plaque with ph Clear Acrylic Spray.

Step 3: Transfer pattern with chalk.

Painting Instructions:

Worm:

Step 1: Base coat the worm's hat with Titanium White. Let dry. Apply as many coats as needed until opaque.

Step 2: Base coat the worm with a mix of light green made from Cadmium Yellow Light and Cerulean Blue. Let dry.

Step 3: Retransfer any detail lines that were covered.

Step 4: Shade the worm with a corner loaded brush of Hookers Green as shown in **Diagram #1**.

Step 5: The cheek is a quarter circle stroke of Napthol Red Light with a small highlight of Titanium White.

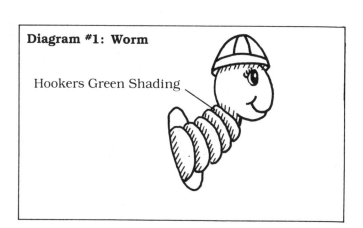

Diagram #1: Worm

Hookers Green Shading

Step 6: The eye is painted with Mars Black and highlighted with Titanium White. Refer to **Diagram #2**.

Step 7: Outline the worm in thin, ink like Black using your Liner or Scroll brush.

Stem:

Step 1: Stem is base coated with Burnt Umber. Let this dry and apply another coat if necesary.

Stem:

Step 1: Stem is base coated with Burnt Umber. Let this dry and apply another coat if necessary.

Step 2: Highlight the stem with White on a #4 or #6 Flat Acrytole brush. Lettering and stroke work is painted with ink like consistency Mars Black.

Finishing:

Finish with several light coats of Aqua Tole Waterbase Varnish.

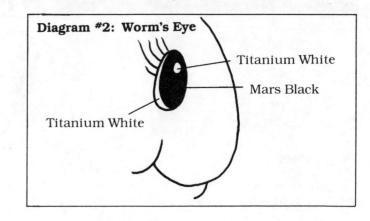

Diagram #2: Worm's Eye

Titanium White

Mars Black

Titanium White

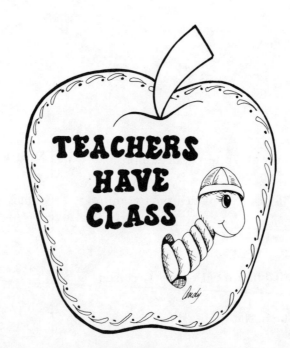

Froggy Bathroom

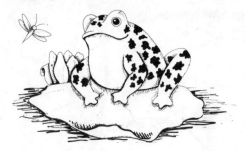

Froggy Bathroom

Leaping from lily pads, these bright green frogs are sure to brighten up any bathroom. Don't delay another minute, get out some paints and brushes and hop to it!!!!

Materials:

Palette: Permalba Acrylics: Cadmium Yellow Light, Cerulean Blue, Titanium White, Hookers Green, Mars Black, Yellow Ochre, Burnt Sienna, Raw Umber, Chrome Oxide Green, Permanent Green Light, and Phthalo Blue.

Brushes: #6 Flat Acrytole, #2 Flat Acrytole, and #1 Liner Acrytole brushes.

Miscellaneous Items: Acrylic Gel Medium, ph Clear Acrylic Spray, ph Gray Graphite.

Preparation:

The only preparation necessary for this particular bathroom set was a light misting of ph Clear Acrylic Spray to seal. Transfer pattern with chalk.

Painting Instructions:

Step 1: Base coat the frog with Titanium White, if one coat does not cover, allow it to dry and apply a second coat.

Step 2: Add a small touch of Cerulean Blue to some Cadmium Yellow Light to make a bright "Spring green".

Step 3: Base coat the frog with the "Spring green". Let dry.

Step 4: Re-transfer any lines that were covered up with the green.

Step 5: Corner load a #6 Flat brush with Hookers Green and apply shading as shown in the diagram and on the Color Worksheet **(Diagram #1)**.
Remember when applying shading to work neatly and carefully. Should you get color where you do not want it you can remove it with clean water. If you are unable to remove a mistake, let the paint dry and then repaint.

Step 6: Using your #2 Flat brush and a touch of Hookers Green, begin to paint the spots on the frog. The spots will look more natural if the paint is not completely opaque. Let dry.

Diagram #1: Frog

Spring Green

Hookers Green

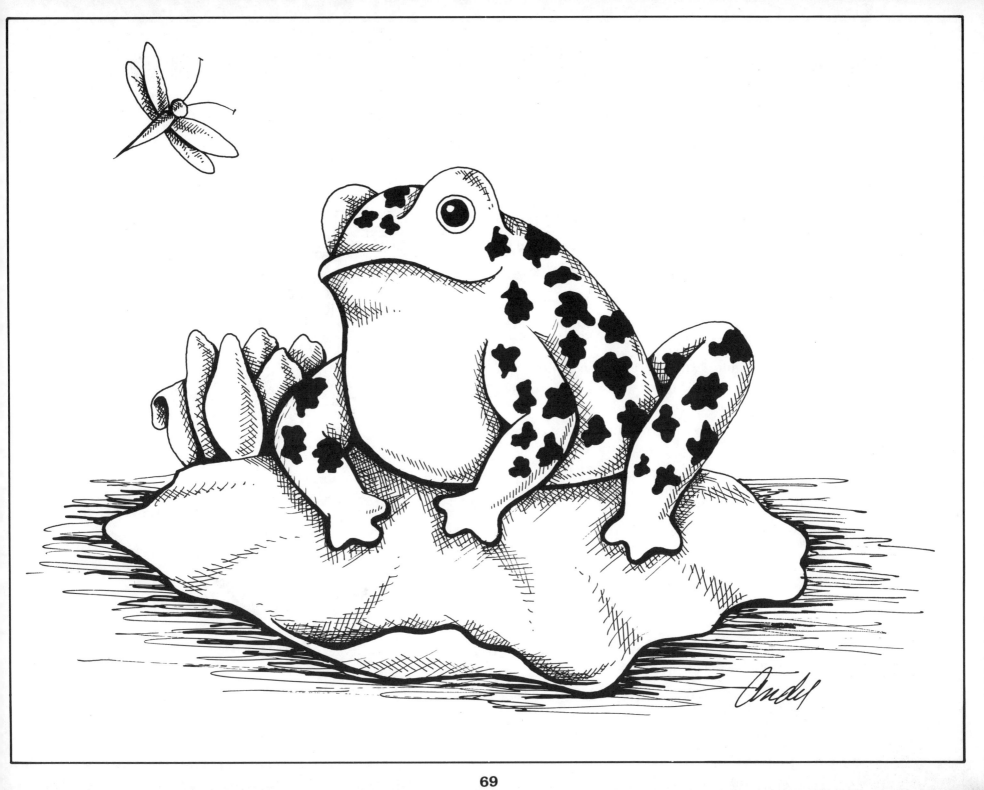

Step 7: On the frog's stomach, brush on a thin coat of Acrylic Gel Medium and while that is wet, pat on a white highlight and blend it into the Gel.

Step 8: Paint the frog's mouth with ink like black paint using your Liner brush.

Step 9: Base coat the entire eye with Yellow Ochre. Let dry. Then apply a wash of Burnt Sienna over Yellow Ochre area. Let dry. Paint the pupil of the eye with black. Let dry. Apply a highlight of Titanium White to the eye with your Liner brush.

Dragon Fly:

Step 1: Base coat the body of the dragon fly with Raw Umber. Let dry.

Step 2: Add a small highlight of Titanium White to the head and body.

Step 3: Base coat the wings with the white and allow to dry.

Step 4: Apply a thin coat of Acrylic Gel Medium to the wings.

Step 5: While this is wet, corner load a small brush with Phthalo Blue and shade as shown in **Diagram #2.**

Step 6: Antennae are painted with thin Raw Umber lines.

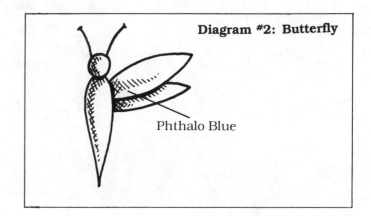

Diagram #2: Butterfly

Phthalo Blue

Water Lily:

Step 1: Base coat the entire lily with Titanium White. Let dry, apply a second coat if necessary.

Step 2: Double load a #6 Flat brush with Raw Umber on one side and Titanium White on the other side. Blend on the palette to soften the color, and shade the lily as shown in **Diagram #3.**

Step 3: Using your Liner brush and thin consistency Raw Umber, outline the petals.

Lily Pad:

Step 1: Base coat the lily pad with several coats of Chrome Oxide Green. Let each coat dry before applying another.

Step 2: Corner load a large Flat brush with a mixture of Hookers Green and Black. Shade around the lily as shown on the Color Worksheet.

Step 3: Highlight the edges of the lily pad with Permanent Green Light with a corner loaded brush. Let dry.

Step 4: Highlight the edges of the pad a bit more with a mixture of Permanent Green Light and White. Let dry.

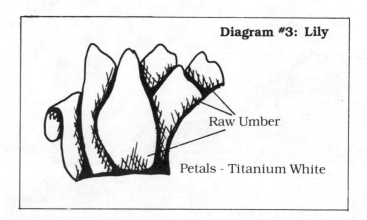

Diagram #3: Lily

Raw Umber

Petals - Titanium White

Water:

Step 1: To paint the water area, brush on a thin coat of Acrylic Gel Medium.

Step 2: While this is still wet, begin brushing some Phthalo Blue into the water area.

Step 3: While the water is still wet, brush on a few Titanium White highlights. Let dry.

Step 4: Now go back and add a few more pure Titanium White highlights to make the water sparkle.

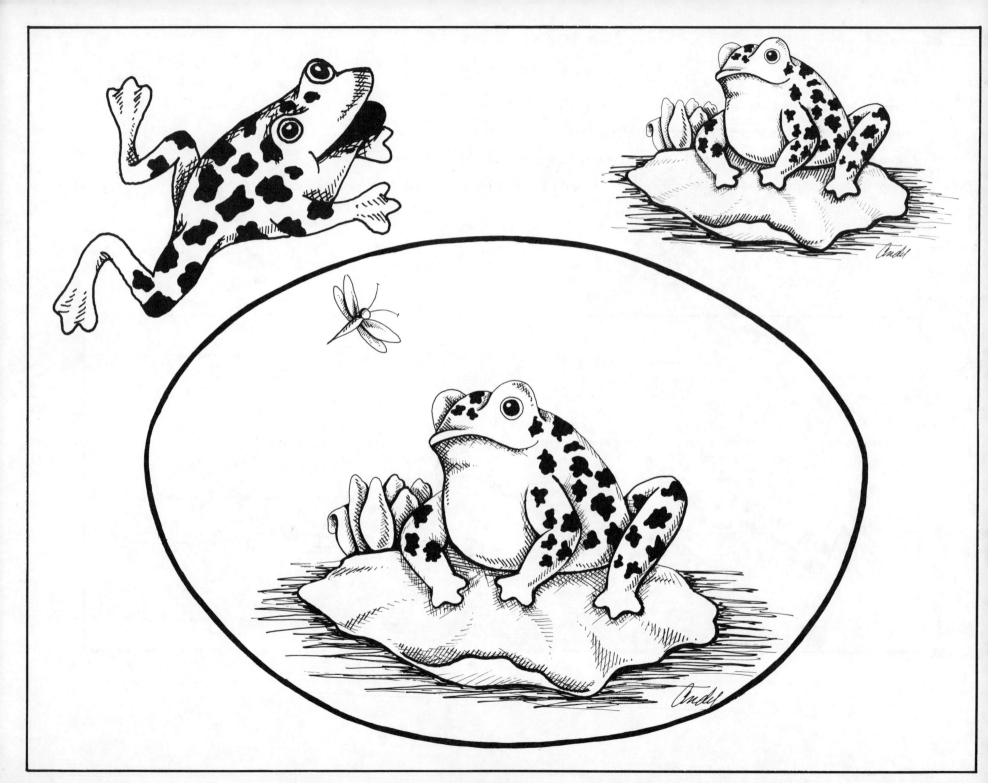

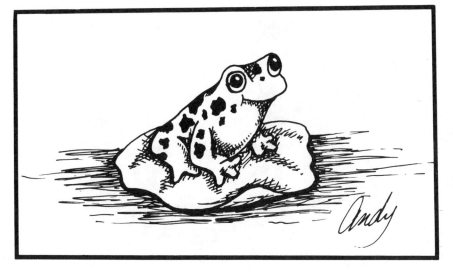

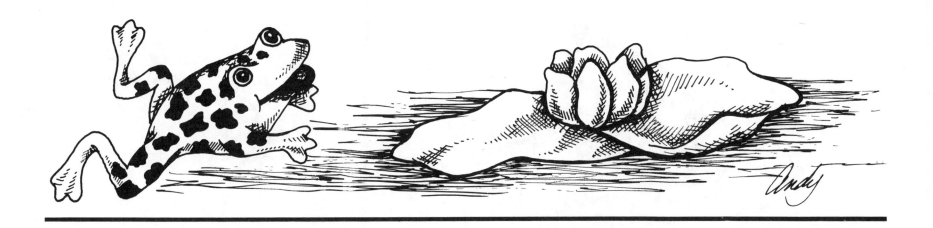

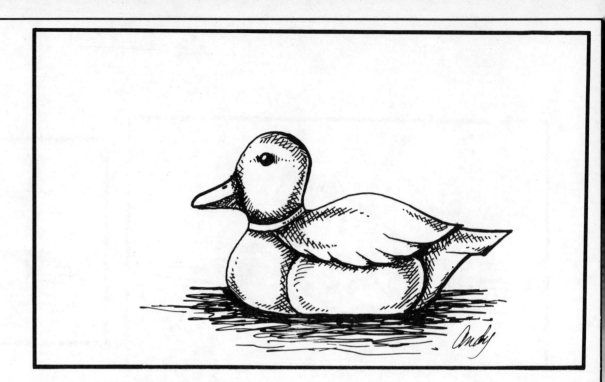

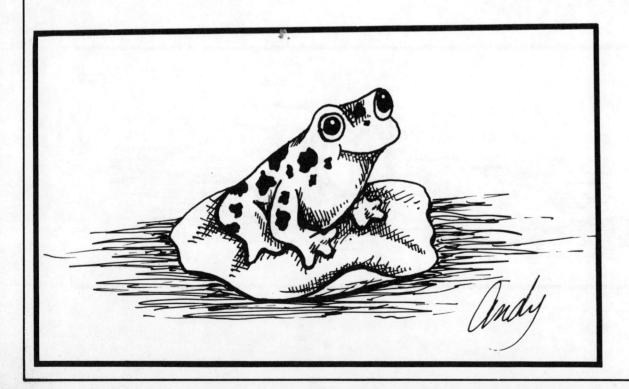

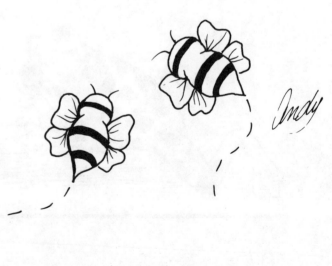

Lion and Blue Worksheet

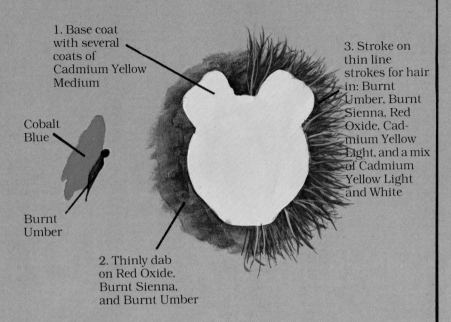

1. Base coat with several coats of Cadmium Yellow Medium

3. Stroke on thin line strokes for hair in: Burnt Umber, Burnt Sienna, Red Oxide, Cadmium Yellow Light, and a mix of Cadmium Yellow Light and White

Cobalt Blue

Burnt Umber

2. Thinly dab on Red Oxide, Burnt Sienna, and Burnt Umber

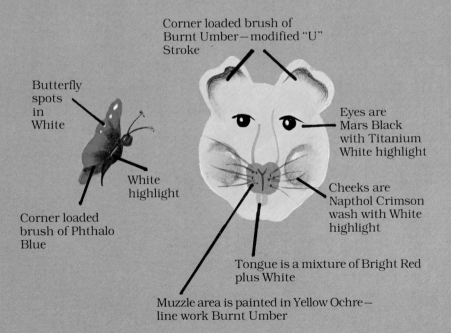

Corner loaded brush of Burnt Umber—modified "U" Stroke

Butterfly spots in White

Eyes are Mars Black with Titanium White highlight

Corner loaded brush of Phthalo Blue

White highlight

Cheeks are Napthol Crimson wash with White highlight

Tongue is a mixture of Bright Red plus White

Muzzle area is painted in Yellow Ochre— line work Burnt Umber

Nose and Whisker line work is Burnt Sienna

Spotty Giraffe Worksheet

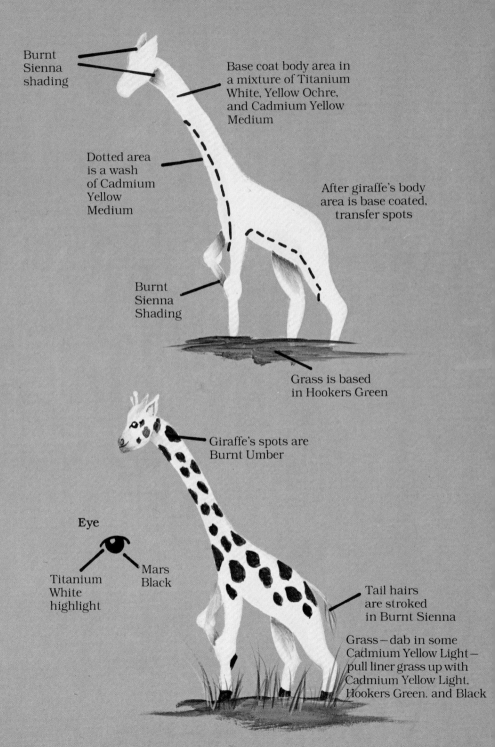

Burnt Sienna shading

Base coat body area in a mixture of Titanium White, Yellow Ochre, and Cadmium Yellow Medium

Dotted area is a wash of Cadmium Yellow Medium

After giraffe's body area is base coated, transfer spots

Burnt Sienna Shading

Grass is based in Hookers Green

Giraffe's spots are Burnt Umber

Eye

Titanium White highlight

Mars Black

Tail hairs are stroked in Burnt Sienna

Grass—dab in some Cadmium Yellow Light— pull liner grass up with Cadmium Yellow Light, Hookers Green. and Black

Buzzin' Bees Worksheet

Bees

Base coat body area in Titanium White

Base coat body area in Cadmium Yellow Medium

Gel

Paint wings in Acrylic Gel Medium

While Gel is still wet on wings corner load a Flat brush with White and stroke on outer edge of wing

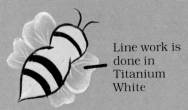

Line work is done in Titanium White

Line work on bee's body is stroked on in Mars Black

Lettering

BEE

Base lettering in Red Hot Base Coat using a small Flat brush or Liner brush

Wiggly Worm Worksheet

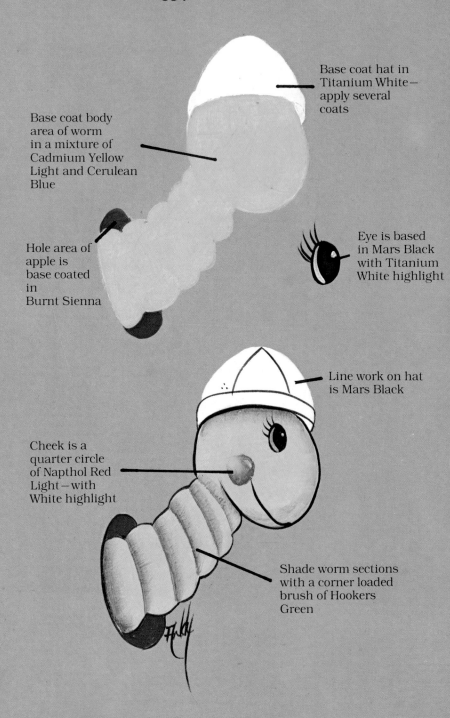

Base coat hat in Titanium White— apply several coats

Base coat body area of worm in a mixture of Cadmium Yellow Light and Cerulean Blue

Eye is based in Mars Black with Titanium White highlight

Hole area of apple is base coated in Burnt Sienna

Line work on hat is Mars Black

Cheek is a quarter circle of Napthol Red Light—with White highlight

Shade worm sections with a corner loaded brush of Hookers Green

Froggy Bathroom Worksheet

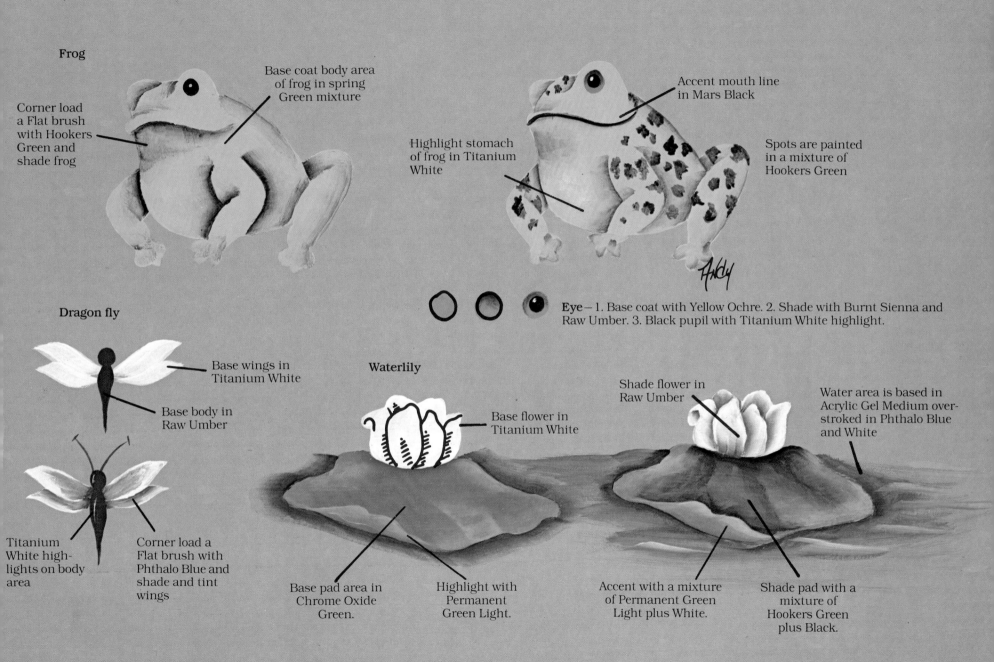

Frog

Corner load a Flat brush with Hookers Green and shade frog

Base coat body area of frog in spring Green mixture

Accent mouth line in Mars Black

Highlight stomach of frog in Titanium White

Spots are painted in a mixture of Hookers Green

Eye — 1. Base coat with Yellow Ochre. 2. Shade with Burnt Sienna and Raw Umber. 3. Black pupil with Titanium White highlight.

Dragon fly

Base wings in Titanium White

Base body in Raw Umber

Titanium White highlights on body area

Corner load a Flat brush with Phthalo Blue and shade and tint wings

Waterlily

Base flower in Titanium White

Shade flower in Raw Umber

Water area is based in Acrylic Gel Medium overstroked in Phthalo Blue and White

Base pad area in Chrome Oxide Green.

Highlight with Permanent Green Light.

Accent with a mixture of Permanent Green Light plus White.

Shade pad with a mixture of Hookers Green plus Black.

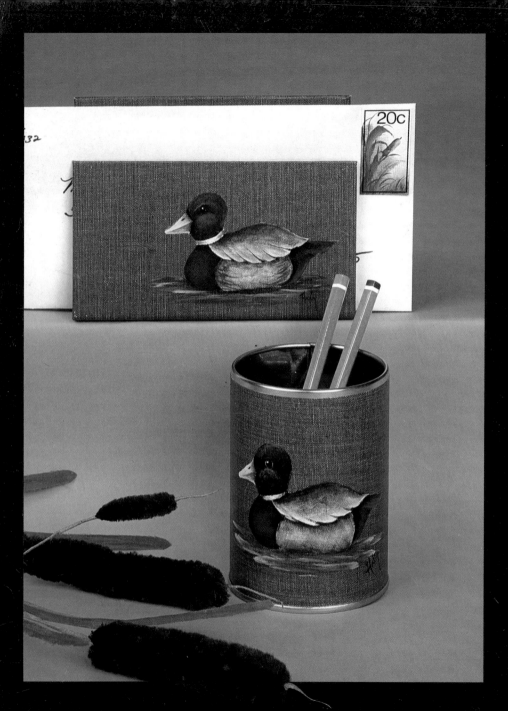

Mallards for Dad

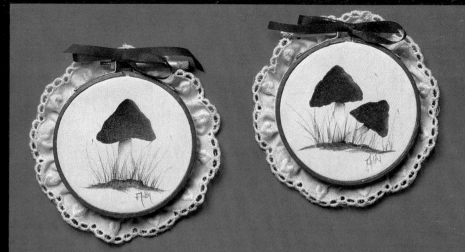

Hoop Hoop Hurrah for Mushrooms

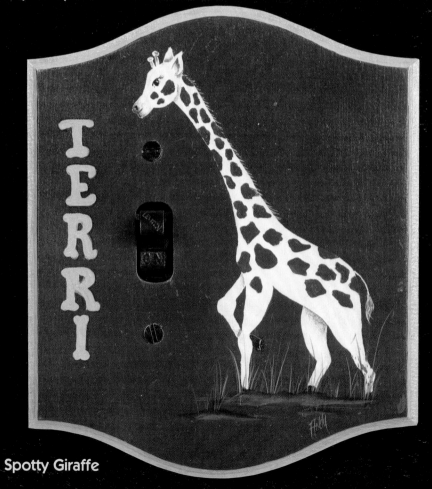

Spotty Giraffe